THE CHESTER BEATTY LIBRARY

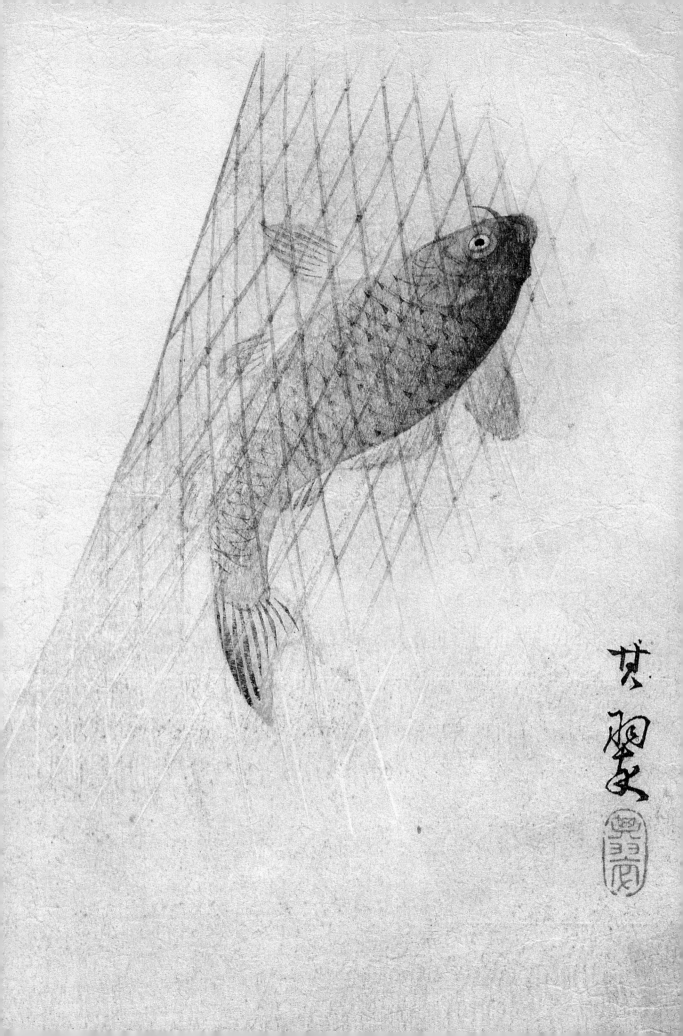

THE CHESTER BEATTY LIBRARY

MICHAEL RYAN, Director and Librarian

CHARLES HORTON, Curator of the Western Collections

CLARE POLLARD, Curator of the East Asian Collections

ELAINE WRIGHT, Curator of the Islamic Collections

LEABHARLANN
Chester
Beatty
LIBRARY

SCALA

THE CHESTER BEATTY
LIBRARY, DUBLIN
IN ASSOCIATION WITH
SCALA PUBLISHERS, LONDON

First published in 2001 by Scala Publishers Limited
4th Floor, Gloucester Mansions
140A Shaftesbury Avenue
London WC2H 8HD

Distributed outside The Chester Beatty Library
in the book trade in the USA and Canada by
Antique Collectors' Club Limited
Market Street Industrial Park
Wappingers' Falls
NY 12590

ISBN: 1 85759 236 0

All measurements are in centimetres.
Height precedes width precedes depth.
Coordinated and edited by Grapevine Publishing Services
Designed by Anikst Design
Produced by Scala Publishers Limited
Printed and bound in Italy

Photographs copyright the Chester Beatty Library, with thanks to Louis
Pieterse, Roy Hewson and Barry Mason.
Front cover: *Emperor Awrangzib Receives Prince Mu'azzam*, AD c.1707-12,
India
Back cover: *The Archangel Michael*, 19th century, Ethiopia
Frontispiece: *Fish in Net*, 19th century, Japan

CONTENTS

The Irish-American mining engineer Alfred Chester Beatty, born in 1875 in New York, was a remarkable man who achieved early success in his chosen career. The wealth that flowed from this success allowed him to follow his collector's instincts and to reflect in his acquisitions his interest in the arts of the East and the West. His world-renowned collections range from delicate Chinese silk paintings and Japanese woodblock prints to exquisite illuminated copies of the Qur'an and European medieval and renaissance manuscripts.

He moved the greater part of his Collections to Ireland in the early 1950s and housed them in a small library and gallery in the Dublin suburb of Ballsbridge. On his death in the late 1960s, the Collections became the property of a public charitable trust in accordance with his will. However, the limited facilities at the suburban location did not allow for the effective display and conservation of the Collections. In recent years, on the initiative of the Director and with the support of the public authorities, a careful study identified a suitable site within Dublin Castle, itself an historic city-centre location dating back to the early thirteenth century.

The Chester Beatty Library at Dublin Castle was formally opened to the public on 7 February 2000, the 125th anniversary of Sir Alfred Chester Beatty's birth. Since then, the new facilities and the splendid display of the treasures of the Collections have attracted widespread interest from domestic and overseas visitors. The Collections are housed in purpose-built galleries (The CBL Galleries), employing sophisticated display and conservation technologies, while a well-equipped reference library and reading room provide excellent study facilities for the scholar and interested visitor. An extended programme of public information about the Collections is now a feature, with regular lecture series and an ambitious programme of education and outreach.

T.P. Hardiman
Chairman, Trustees of the Chester Beatty Library

Sir Alfred Chester Beatty (1875–1968) is best remembered today as a distinguished book-collector. His career as a mining engineer and as an entrepreneur who opened up many areas to mining enterprises in America, Africa and Europe was equally illustrious. A friend of statesmen such as President Hoover and Sir Winston Churchill, he was quietly influential in many ways, especially during the Second World War, when he made an important contribution to the Allied war effort. He was a great benefactor of hospitals and medical research and an enlightened employer.

Chester Beatty was born in New York, of Irish, Scots, English and New England descent. He was educated at Princeton and Columbia universities. He graduated in mining engineering from Columbia in 1898 and began his career working as a labourer in mines in the south-western United States. A millionaire by the age of thirty, he had always been a collector – of minerals and stamps, and later of Chinese snuff bottles, often carved from gemstones. In time, he began to buy books and manuscripts, and by the time he left America for Britain in 1911 he was already a serious and discerning collector, although – unlike some of his contemporaries – not a flamboyant one.

When he came to London, he bought Baroda House in Kensington Palace Gardens, and it soon became filled with his library, which consisted of important printed books, European and Persian manuscripts and Old Master prints. A widower with two young children when he left America, he remarried in 1912, and he and his new wife, Edith Dunn, honeymooned in Egypt. He eventually bought a house in Cairo, where he frequently spent the winters and where his interest in Islamic culture was intensified. A voyage to Asia in 1917 stimulated his interest in Chinese and Japanese painting, and a number of fine painted scrolls and albums was added to his collection. His wife collected decorative art objects and Impressionist paintings.

1 Chester Beatty, the miner, *c*.1905.
2 Alfred Chester Beatty in 1950, by Colin Colahan © Mrs Monique Colahan.

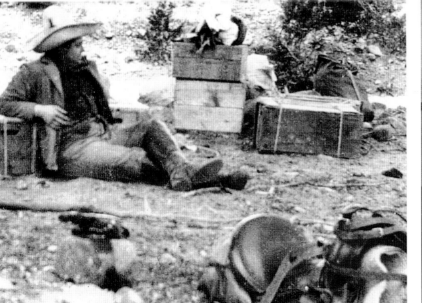

1

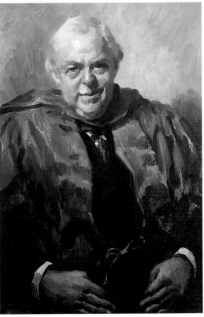

2

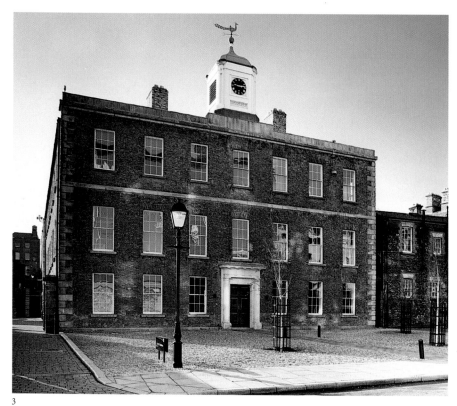

3

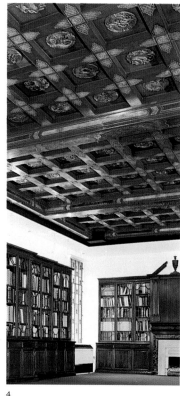

4

Taking professional advice, he began to develop his collections, acquiring very important Islamic material – especially a brilliant collection of illuminated copies of the Qur'an, and Mughal, Turkish and Persian manuscripts, all of the highest quality. His Christian holdings were enhanced by acquisitions of Coptic, Syriac and Greek manuscripts. Almost by chance in the late 1920s he acquired a group of papyrus texts which, on conservation, proved to contain exceptionally important biblical, especially New Testament, material. Chester Beatty bought mostly through dealers and in the salerooms through agents, as he himself was reluctant to compete in public for material. At auctions he sometimes worked in partnership with public museums, sharing purchases with them by prior arrangement. Throughout the 1930s he added to his Islamic collections, acquiring not only fine illuminated manuscripts but also plainer texts of scholarship, law and religious commentary. These, some 2,700 manuscripts, are exceptionally important for the study of the history of Islam.

Chester Beatty continued to collect well into the 1960s, and conscientiously arranged for the publication of his holdings. By the time of his death, his collection included not just exceptional Islamic, East Asian and biblical manuscripts but also outstanding Western printed books, Old Master prints, and South-east Asian, Tibetan, Ethiopian and Armenian holdings of great importance. He concerned himself only with the finest-quality works; his discernment, and the helpful connoisseurship of his advisers, ensured that he built up perhaps the finest manuscript collection assembled by a single individual within the twentieth century.

Chester Beatty became a naturalized British subject in 1933 and served on important production and raw materials advisory bodies during the Second World War. He was shocked when the General Election of 1945 returned a Labour government by a

landslide – he could not believe that the people had turned their backs on Churchill, for whom he had unbounded admiration. Post-war austerity did not suit Chester Beatty, who found rising taxes and currency restrictions irksome. He also instinctively disliked socialism. These views, plus a growing sense of disillusionment with his place in the cultural life of London, prompted him to contemplate moving, especially as his active role in business was coming to an end.

In 1949 he visited Ireland, where, as a great collector and leading businessman, senior officials encouraged him to consider setting up his Library in Dublin. He moved his collection in 1950 and in the same year bought a site in Shrewsbury Road to build a new home for his Library. It opened to researchers in 1953 and later, in a limited way, to the public. In 1954 he was knighted by Queen Elizabeth for his wartime services to Britain. Irish honours were conferred on him also, and in 1957 he became the first honorary citizen of Ireland. That year, a new gallery opened to display his collection. In discussions with the government of Ireland, Chester Beatty explored the possibility of leaving his Library in trust for the benefit of the public, and an agreement was reached that, if he did so, the costs of maintaining the institution would be borne by the state.

When Sir Alfred Chester Beatty died in 1968, he was the first private citizen to be accorded a state funeral in Ireland. His will provided for the continuance of his Library as a public charitable trust supported by the state. Now counted as one of Ireland's national cultural institutions, it is unusual in having a constitution more like one of the great American philanthropic foundations. It is owned by its Board of Trustees. In 1997, the terms of service of the Trustees were modernized and, with the consent of the High Court

3 The façade of the Clock Tower Building, remodelled about 1810.

4 The Reference Library, showing the reproduction Chinese ceiling brought originally from Baroda House and moved from Shrewsbury Road in June–July 1999. The bookcases (by Hicks of Dublin) were made for Chester Beatty's Library at Shrewsbury Road, 1950–3.

5 The permanent exhibitions: Buddhism. Standing Buddha on loan from the National Museum of Ireland.

5

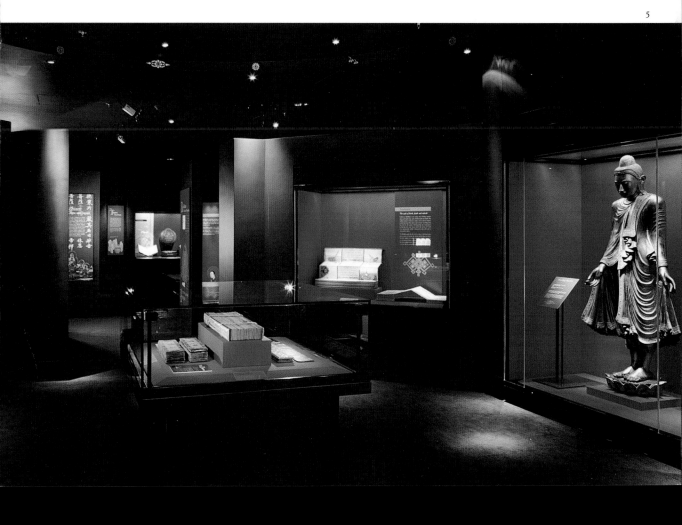

6

in Dublin, provision was made for the appointment of three trustees by the Minister for Arts, Heritage, Gaeltacht and the Islands.

The Chester Beatty Library was initially established in a garden setting in the Ballsbridge area of Dublin. The original buildings were constructed to designs closely monitored by the founder's advisers. By the mid-1960s it had become clear to Chester Beatty that they had outgrown their usefulness, and in his will he stipulated that a new exhibition gallery should be built on the site within four years of his death. The new gallery was opened in 1973, but in time it, too, was overtaken by the need for modern display and conservation measures. The location of the Library was not convenient for visitors, and numbers were low.

In 1993, following a long period of research and planning, the opportunity arose to obtain the Clock Tower Building in the garden of Dublin Castle as a home for the collection. This building, originally constructed c.1752, served variously as military and revenue offices well into the 1980s. A somewhat austere structure, it was partly remodelled in the early nineteenth century, almost certainly by the distinguished architect Francis Johnson.

The building was completely restored and a modern exhibition block added during the 1990s by the Office of Public Works. The old building now houses the offices, reference library, temporary exhibition gallery and other services, while the new block is devoted to exhibition galleries, public services and a roof garden. The Government of Ireland, the European Union Regional Development Fund and the Trustees of the Library jointly funded the redevelopment and relocation of the Library.

Chester Beatty was made a Freeman of Dublin in 1954. The new Library stands on the site of the Dubh Linn ('Black Pool') which gave the city its name.

6 The Clock Tower Building, Dublin Castle, in 2000.
7 The permanent exhibitions: Islam.

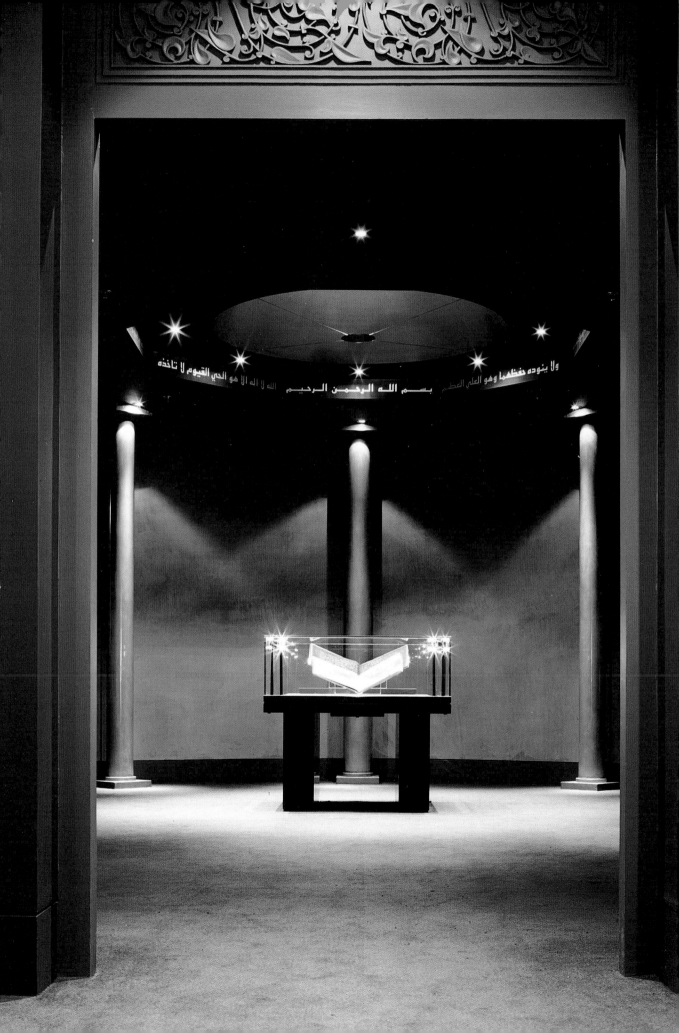

The collection of Western illuminated manuscripts was Chester Beatty's first collection, and it made him famous as a book-collector. Chester Beatty's initial preference for illuminated manuscripts can be deduced from archival sources, as mention is made of French Books of Hours, five of which were in his possession by 1910. After moving to London, Chester Beatty began buying much earlier manuscripts from the Carolingian and Ottonian periods, including some that were not illuminated but were highly important on palaeographical grounds. By the end of the 1920s, Chester Beatty had assembled a collection of well over 200 Western manuscripts, but in the 1930s he sold over 60 from the collection and on his death in 1968 another 70 were disposed of by auction.

Towards the end of the 1920s, Chester Beatty became aware of the availability of manuscripts that were to make his collection even more famous. These were ancient Egyptian papyrus rolls and early Christian papyrus codices. Interest in papyri had largely been the preserve of archaeologists and academics; since such documents were for the most part undecorated, few private collectors had ventured into this area except, perhaps, to purchase individual pieces as examples of ancient writing. Chester Beatty, however, made substantial purchases and his papyrus collection developed into one of the most important private collections in the world. Although the main papyri were purchased through dealers, others were acquired through a museum syndicate, whereby several sponsors of excavations distributed the finds among themselves.

As Chester Beatty acquired more and more Christian texts, he donated most of his ancient Egyptian papyri to the British Museum, keeping only one major piece, the *Love Poems*, and some minor illustrated funerary texts. Today the papyri collection is preserved in over 1,500 glazed frames and includes over 50 complete or substantially complete papyrus codices – one of them the largest known book to survive from antiquity – as well as many substantial fragments.

8 **Decorative initial 'd'**
De Civitate Dei
Latin text on parchment
(Italian Caroline minuscule)
*c.*1100
Northern Italy (Nonantola)
47 × 30.5 cm (full folio)
CBL WMS 43 f. 203r

Although the Library is more famous for its rare and illuminated manuscripts, Chester Beatty collected over 3,000 rare printed books and over 33,000 Old Master prints and drawings. Many of these books are unique editions, artists' proofs or extra-illustrated, as Chester Beatty was not interested in merely acquiring a first edition. Within this collection there are over 1,000 important examples of European bookbinding, which, together with the early papyri and Christian collections, show the development of the Western book from the origin of the codex to some of the finest artists' books of the twentieth century.

FINIT LIBER SEPTI
MUS DECIMUS :
INCIPIT LIBER
OCTAVUS DECIMUS :

E CIUITATE DUAR.

9

9 Contendings of Horus and Seth/Egyptian Love Poems (detail)
Hieratic text on papyrus
c.1160 BC
28 × 585.0 cm (entire scroll)
CBL Papyrus Chester Beatty I

This papyrus scroll contains a number of texts and, unusually, it has been written on both sides. Apart from a series of business transactions and a text in praise of Rameses V (which helps to date the scroll), the most important text is a series of love poems or songs. These are similar in style to the Song of Solomon found in the Christian Old Testament, where one lover extols the virtues (and physical delights) of the other. Its very early date makes this one of the most important literary scrolls in the world, and an extraordinary witness to universal human passions. The scroll also contains the New Kingdom story of the Contendings of Horus and Seth, which is well known from the hieroglyphs at the Temple of Horus at Edfu, in Upper Egypt, where the saga was re-enacted ritually as miracle plays. Horus, the son of Isis and Osiris, challenged Seth, the murderer of Osiris. The contest involved battles, sexual deceit and courtroom drama in front of the gods before Horus was eventually declared the champion.

10

10 **Book of Breathings (detail)**
Demotic text on papyrus
*c.*AD 100
CBL Papyrus Chester Beatty XXa

The *Book of Breathings* is the ancient
name given to two Egyptian texts
found from the Ptolemaic to the
Roman period. This example
belonged to Khonsdjehuty, a treasury
guard of the house of Amen. This
vignette shows the embalmer-god
Anubis leading Khonsdjehuty to
Osiris, behind whom stand Isis,
Horus and Nephthys.

For many visitors, the greatest Christian treasures to be seen are the early New Testament papyri. These incredible discoveries were made public in *The Times* on 19 November 1931, as a consequence of which Chester Beatty received many letters offering him rare books and manuscripts, including one supposedly written 'by Jesus'.

Before this find, the earliest and most important manuscripts of the Greek New Testament were parchment codices from the fourth and fifth centuries, all dating from the period after Constantine had granted toleration to Christianity. Only a few small fragments of papyrus containing portions of the New Testament from an earlier date were known, and most of these were too small to be of much significance.

The publication of the Chester Beatty New Testament papyri caused a sensation, as they were at least 100 years older than the most important parchment codices. They not only contain much larger portions of the New Testament than any previously known papyri, but they also provide a unique witness to the biblical text at a time when Christianity faced extensive persecution and the destruction of Christian scriptures.

By acquiring these early Christian texts, including the earliest surviving Gospel book, the earliest copy of Saint Paul's Letters and the earliest copy of the Book of Revelation, as well as many other early or unique versions of homilies, epistles or pseudo-canonical texts, Chester Beatty's Library became one of the major centres in the world for the study of the Christian Bible.

11

11 **Gospel of Saint John**
Greek text on papyrus
*c.*AD 150–200
7 × 4 cm
CBL Ac. 2555 (𝔭66)

This fragment, dated to the second half of the second century AD, is among the oldest Gospel texts in the world. It contains part of John's account of the Crucifixion (Chapter 19, verses 25–8), wherein Jesus tells John to take care of His mother.

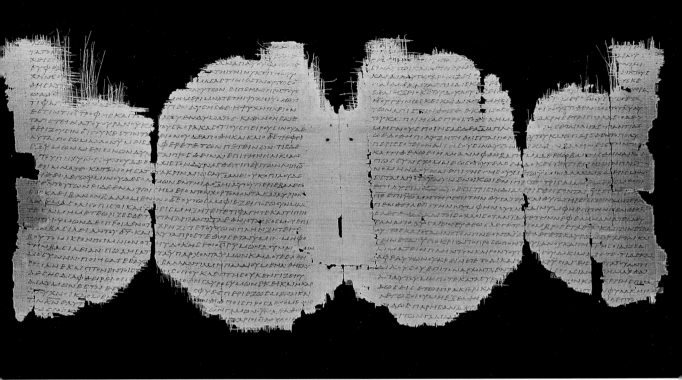

12

12 Gospel of Saint Luke

Four Gospels and Acts of the
Apostles
Greek text on papyrus
c.AD 250
25.5 × 20 cm
CBL Biblical Papyrus I (𝔭 45)
ff 13r–14r

This Chester Beatty papyrus codex
is the oldest book in the world to
contain these New Testament texts
in a single volume. Until its
discovery, only small papyrus
fragments of single Gospels were
known. This book showed that the
four Gospels and the Acts were
compiled into one volume much
earlier than many scholars had
expected. In total, parts of 60 out
of an estimated 220 leaves survive.
The folios containing Mark and
most of Luke's Gospel are the
oldest known copies of these texts.

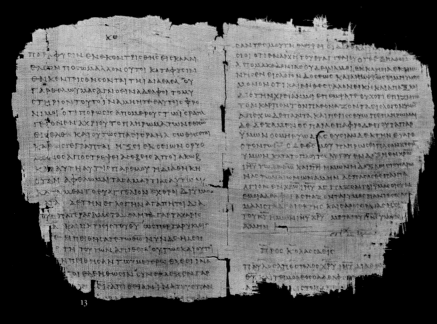

13

13 Letter to the Romans
Letters of Saint Paul
Greek text on papyrus
c.AD 180–200
28 × 16.5 cm
CBL Biblical Papyrus II (𝔭46)
bifolia 15r and 90r

The Chester Beatty papyrus
codex of the Pauline Epistles is
the earliest book of Saint Paul's
letters in existence. It contains
some of Paul's letters to the
early Christian communities in
Asia Minor. The pages were
numbered in the upper margin,
and enough page numbers
have been preserved to establish
the original formation of the
volume. The entire codex would
have consisted of 100 to 104
leaves, of which only 86 survive,
55 in Dublin and 30 in the
library of the University of
Michigan.

14 Book of Revelation
Greek text on papyrus
c.AD 250
18 × 12 cm
CBL Biblical Papyrus III (𝔭47) f. 5r

This papyrus codex
contains Chapters 9–17 of
the Apocalypse or Book of
Revelation of Saint John. The
surviving portion of the text is
the largest single section of the
text preserved on papyrus, and
it is the oldest surviving
manuscript of most of this
work. The Book of Revelation
is the final book of the New
Testament. It belongs to
a tradition of ancient
apocalyptic literature in which
the secrets of the world are
revealed. It is generally accepted
that it was originally written
around AD 90–5.

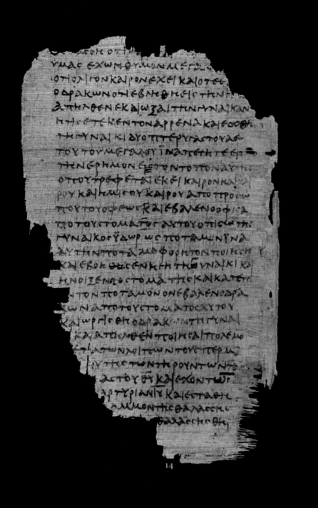

14

15 **Epistles of Saint Pachomius**
Greek text on parchment roll
*c.*AD 350
74 × 15.2 cm
CBL WMS 145

The text of this manuscript
contains some of the letters
of Saint Pachomius
(AD 292–346), who, in
response to a vision,
founded the first Christian
monastic order. Before its
discovery, the epistles were
only known in later Latin
translations and some
Coptic fragments. By virtue
of its great antiquity and the
number of lines of text that
survive, this Greek version
is of great importance.

16

17

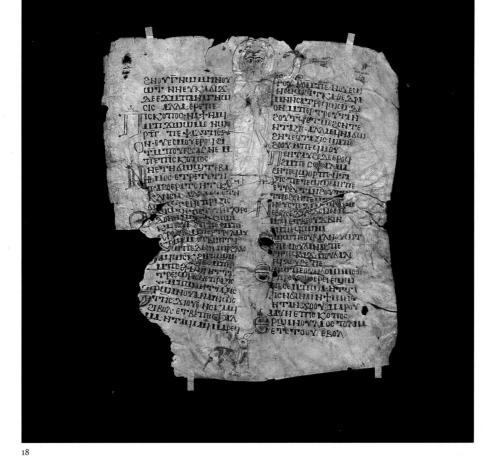

18

16 Ephraem's Commentary on the Diatessaron of Tatian
Syriac text on parchment
c.AD 490–510
23.8 × 15.5 cm
CBL Syc MS 709 ff 45r–44v

Tatian (AD 120–73) composed a harmony of the four Gospels, known as the Diatessaron, which became popular in the eastern churches of the Roman Empire. Later, however, his views were considered heretical, and his writings, including the Diatessaron, were suppressed. Before its suppression, Ephraem the Syrian (d. AD 373) wrote a commentary on the Diatessaron, and this manuscript is the only known copy to contain Ephraem's original Syriac text. As it includes quotations from the Diatessaron, it is also a unique witness to the kind of Gospel text used in Syria between the third and fifth centuries AD.

17 Decorated 'frontispiece' to the Gospel of Saint John
Epistles of Saint Paul and the Gospel of Saint John
Coptic text on parchment
c.AD 600
15.2 × 13 cm
CBL Cpt 813 ff 147v–148r

18 Canons of Saint Basil (detail)
Coptic text on parchment
c.AD 900
29 × 60 cm
CBL Cpt 819

The *Canons of Saint Basil* are a collection of rules relating to church discipline. Originally written in Greek, they were later translated into Coptic and Arabic. The Chester Beatty leaves are the best-preserved and most complete Coptic version so far discovered.

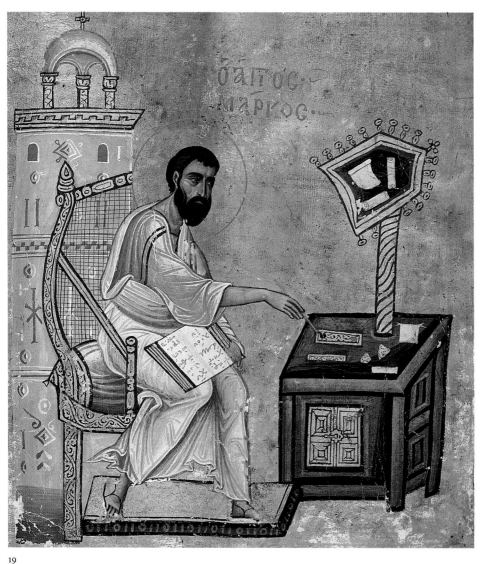

19

19 Saint Mark the Evangelist
Byzantine Gospel Book
Greek text on parchment
*c.*1100
24.7 × 19.6 cm
CBL WMS 139 f. 122V

By the sixth century,
many Gospel books were
beginning to be decorated.
Gradually a 'programme'
evolved to include the
depiction of the four
Evangelists or their symbols,
elaborate canon tables and
decorated letters. The
Evangelists were usually
depicted seated, either at a
desk or lectern, but
occasionally they are
shown standing, as in the
traditional depiction of Old
Testament prophets.

20 Decorated stepped cross
Syriac Gospel Book
(Harklean version)
Syriac text on parchment
*c.*1130
38.5 × 30.5 cm
CBL Syc. MS 703 f. 16v

South-east Turkey, Syria
and parts of Iraq were once
predominantly Christian.
The language spoken was
Syriac, until it was replaced
by Arabic in the thirteenth
century. In AD 508 a version
of the New Testament was
completed in Syriac, which
was revised by Thomas of
Harkel (Heraclea) in AD
616. This revision is known
as the Harklean version.
Syriac Christians were very
active missionaries and they
brought Christianity to
India and Ethiopia and, by
AD 781, to China.

21 Christ, the donor and scribe
Four Gospels
Bolorgir script on vellum
1342
20.5 × 14.5 cm
CBL Arm MS 614 f. 13v

This manuscript was
written by Sargis Pidsak,
a well-known Armenian
scribe and illuminator.
In this miniature he has
included himself (on the
right) along with the donor,
a priest, Tiratsu (on the left)
kneeling in homage. Two
other portraits of this artist
survive, but this example is
the latest of the three, where
the artist has depicted
himself as an old man.

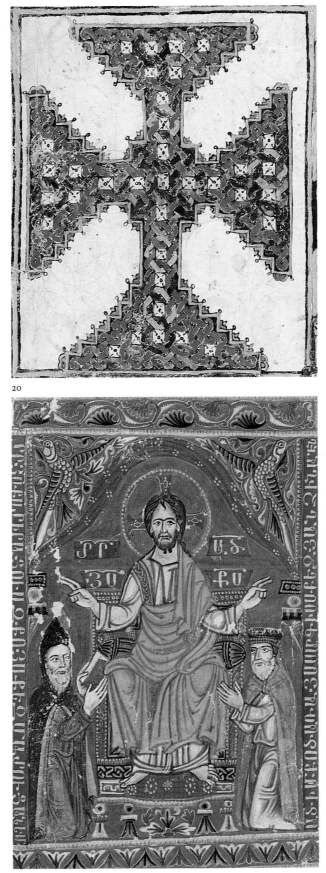

20

21

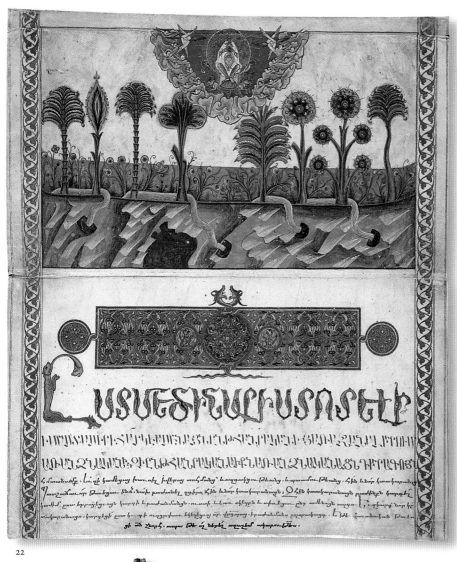

22

22 The Garden of Eden
Armenian Abridged Bible
Bolorgir script on parchment
1601
30.5 × 17.5 cm (each folio)
CBL Arm MS 551 ff 1–2

The author of this abridged
version of the Bible,
Serapion of Edessa, is a
well-known figure in
Armenian church history.
An influential scholar and
teacher, he was elected
co-catholicos (or pope) in
1603. The Abridged Bible
was written because of the
'laziness of pupils or
readers' who did not want
to read the whole text.
 The colophon to this
copy, written by the
'sinful' scribe, Hohannes,
tells us that Serapion
commissioned this volume
for his own enjoyment
and as a memorial to his
parents. The illuminations,
beginning with the Garden
of Eden headpiece, were
painted by the 'adolescent'
Aslan, who was 'gifted in all
things and in the painting
and writing of the three
alien nations, Persians,
Arabs and Turks.'

23 Armenian jewelled binding
17th century
Filigree silver with coloured
stones
14.5 × 10.5 cm
CBL Arm MS 584

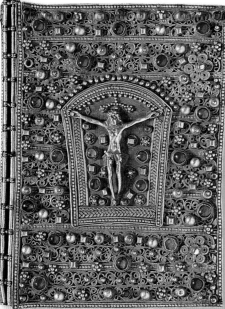

23

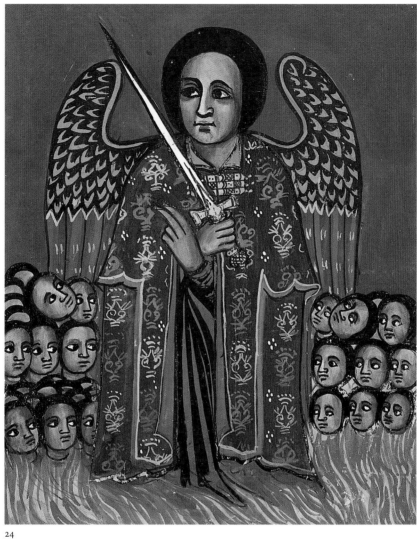

24

24 **The Archangel Michael
 and the souls of the damned**
Homilies of Saint Michael
(*Dersana Mika'el*)
Ge'ez text on parchment
19th century
Ethiopia
34 × 27 cm
CBL Eth MS 953 f. 12r

Tucked away among the pages of European illuminated manuscripts are some wonderful and intriguing works of art. Scribes and illuminators combined silver and gold leaf with lapis lazuli and other mineral pigments to produce a dazzling range of colours that brought to life the images conveyed by the texts they copied. These images, confined within the shapes of letters or miniature panels, all struggled to interweave the power of the written word with illustration and the sense of vision.

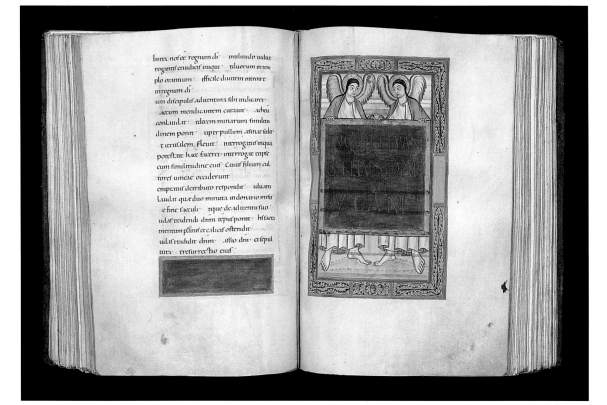

25

25 **Beginning of the Gospel of Saint Luke**
Stavelot Gospel Book
Latin text on parchment
*c.*1000
Flemish
30.7 × 22.2 cm
CBL WMS 17 f. 117V–118R

In the medieval period, book production was largely in the hands of monks, who copied the religious texts in the great monasteries of Europe and the Middle East. The Benedictine abbey of Stavelot was one of several monasteries in the Meuse (Maas) region of modern Belgium that produced fine manuscripts. This magnificent Gospel book was written and illuminated about the year 1000. The quality of the vellum, the extent of the intended and executed decoration, the abundant use of gold and the purple-stained vellum all suggest an imperial association with the court of Emperor Otto III (AD 980–1002).

In many scripts or national hands, initial letters became the main object of decoration, acting as signposts to indicate new verses or chapters to the reader. These initials, drawn very large, such as those that introduce the beginning of each Gospel, or set apart in the margin, are great pillars of strength around which the religious texts are woven. They often contain designs of great complexity and imagination, and it was not very long before scribes, who were proud of their writing skills, embellished these letters further by introducing realistic scenes, giving rise to the 'inhabited letter'.

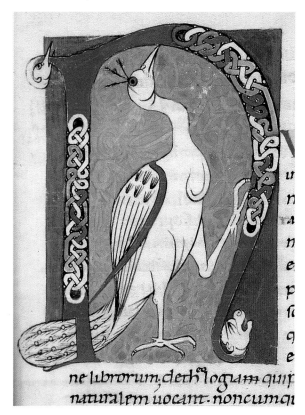

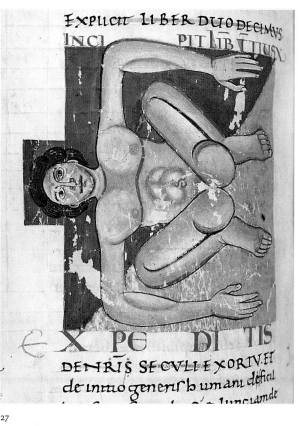

26

27

26 Decorative initial 'N'
De Civitate Dei
Latin text on parchment
(Italian Caroline minuscule)
*c.*1100
Northern Italy (Nonantola)
47 × 30.5 cm
CBL WMS 43 f. 80r

27 Decorative initial 'E'
De Civitate Dei
Latin text on parchment
(Italian Caroline minuscule)
*c.*1100
Northern Italy (Nonantola)
47 × 30.5 cm
CBL WMS 43 f. 133v

The 'inhabited letter' was the favourite form of decoration in Romanesque manuscripts. Usually the loop of the letter contains animals and figures, intertwined foliage or complex geometrical patterns. In some cases the shape of the letter is quite obscured by the decoration.

The twelfth century was also a period of experimentation and change. Scribes played around with the letter shapes and often combined letters in new ligatures to suit the overall pattern of the text. A sense of movement was created on the page as letters moved in and out of each other, in alternating colours. In many parts of Europe new scripts were evolving, and the decoration of manuscripts changed as the miniature became the main element of decoration.

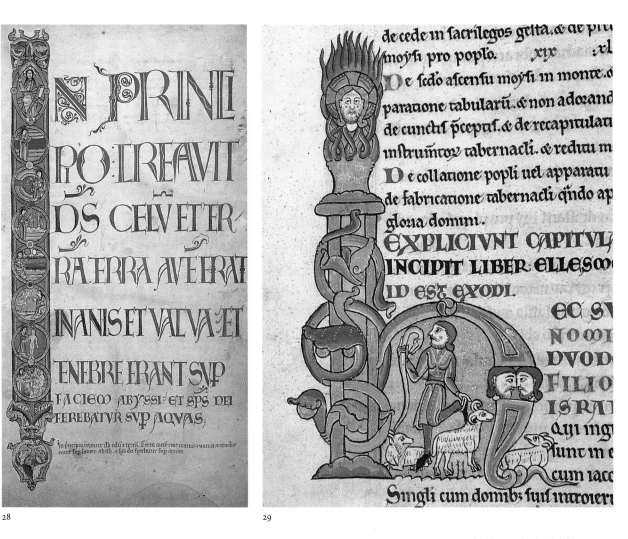

28

29

28 **Decorative initial 'I'**
Walsingham Bible
Latin text on parchment
(English minuscule)
*c.*1153
English
47.3 × 31.7 cm
CBL WMS 22 f. 8v

29 **Decorative initial 'H'**
Walsingham Bible
Latin text on parchment
(English minuscule)
*c.*1153
English
47.3 × 31.7 cm
CBL WMS 22 f. 32v

30 **Virgin and Child with saints and penitents**
Statutes and Matricola of the Guild of Innkeepers
Latin text on parchment
(Angular Italian hand)
1379
Italy (Perugia)
33 × 23 cm
CBL WMS 78 f. 2v

This manuscript is a collection of rules and regulations for the Guild of Innkeepers at Perugia for the years 1379–1431. The miniature is attributed to the Perugian miniaturist, Mattheus Ser Cambi, and is regarded as one of the finest of its type. The Virgin and Child are seated on a raised throne with two saints on either side. Saint Laurence holds a pen and a book while Saint Herculanus holds a banner displaying the symbol of Perugia. The other two saints are bishops, one of whom is Saint Constantius. In the foreground the artist has painted seven unidentified members of the guild, who kneel in homage.

The Gothic style first appeared in the architecture of northern France in the twelfth century. Its motifs, such as pointed arches and the general elongation of figures, soon found their way into painting and manuscript illumination. In Gothic illumination the marriage between illustration and decoration tended to be more successful than in the Romanesque period, and the miniature in particular, rather than the initial, became a major art form. The finest early Gothic illuminated manuscripts were produced in France, and Paris in particular became a major centre for illumination. Other important ateliers were to be found in Bruges, Ghent and Brussels and in the north Italian city states.

30

Miniatures are illustrations to the text that are either full-page panels or smaller paintings inserted into the text. Originally the word did not refer to the small size of these paintings but to the red pigment, *minium*, which was frequently used. The Latin word *miniare* means to write or paint in this colour. In many of these miniatures, medieval illuminators depicted scenes of everyday life, and by looking closely we can witness the labours of the various times of the year, simple everyday chores or distractions. Religious scenes are often shown in near-contemporary settings, such as castles or churches, with the Virgin or saints depicted in the dress and fashions of the period.

31 **Gratiani Decretum with glosses**
(Concordia discordantium canonum)
Latin text on parchment
(Italian minuscule *Bononiensis*)
*c.*1300
Italy (Bologna?).
Illuminated in Paris
40.5 x 28 cm
CBL WMS 66 f. 254v (detail)

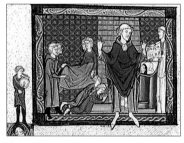

31

32

Church law or Canon law held three jurisdictions: over people, particularly clerics, over issues, such as church organizations, marriages, wills, vows, and contracts resting on good faith; and over sins, heresy, schism and perjury. Over 3,800 of these laws were organized and interpreted by the Benedictine monk Gratian (d. before 1159), who compiled his *Decretum* about 1140. The illuminated miniatures in this illustrated copy were painted in Paris and they depict several thorny problems that vexed the mind of the medieval cleric. In this example, a priest conducts a wedding mass for a couple who have had children out of wedlock.

32 **Saint Francis preaching to the animals**
Psalter
Latin text on parchment
*c.*1250
Flemish (Ghent–Bruges)
15.5 x 11.5 cm
CBL WMS 61 ff 135v–136r

The Psalter, or Book of Psalms, was the most common form of private devotional book in the early Middle Ages. Initially all 150 psalms were to be recited in a day, but gradually they were divided into sections which were read or sung at particular times or canonical hours of the day. Besides the decorative initials, it became a practice to produce a group of full-page miniatures or cycle of miniatures before the Psalms. These were often Old Testament scenes with New Testament parallels, but gradually the iconography became entirely Christian.

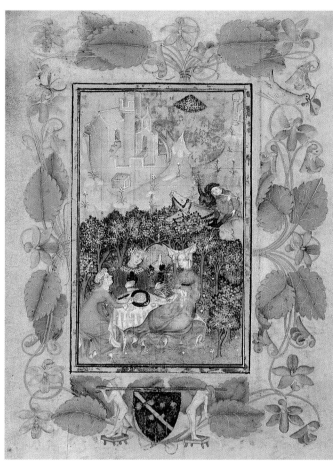

33

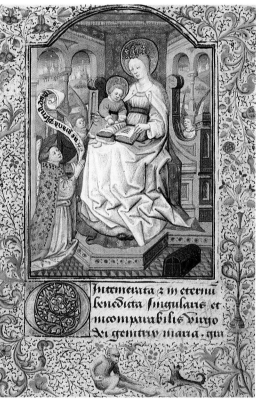

34

33 Book of Hours (Use of Paris)
Latin text on vellum
c.1420
French (Châlon-sur-Marne?)
19.2 × 13.2 cm
CBL WMS 94 f. 6r

The most common book
to survive from the late
medieval period is the Book
of Hours. These books are
collections of prayers for
private devotional use
rather than for liturgical
use or the Divine Office.
Almost all were produced
in commercial workshops,
and although many were for
rich patrons, more humble
examples were written
for small merchants or
craftsmen. Over time the
general example became
rather stereotyped, with 6, 12

or 24 full-page miniatures,
depending on the purse of
the patron. Like Psalters,
many Books of Hours can
be localized because of the
inclusion of local saints'
feast days in the calendar
and the form of liturgical
use in the various Offices.
 The illumination of this
Book of Hours is quite
unusual, as the drawing is
extraordinarily delicate and
the colours are unusually
light. There are ten full-
page miniatures in the
calendar and nine three-
quarter-page miniatures,
all within borders of
flowers, amoretti, insects
and animals, many of
which can be identified.

**34 The Coëtivy Book of Hours
(Use of Paris)**
Latin text on vellum
c.1443
French
13 × 10 cm
CBL WMS 82 f. 209r

This magnificent Book of
Hours was executed for
Prigent de Coëtivy (1400–50),
who was Admiral of France
and, next to the Duc de
Berry, one of the greatest
book-collectors of the period.
The 148 miniatures are
mainly attributed to the
'Master of the Duke of
Bedford' or 'Bedford
Master', the chief
illuminator of the time,
whose Paris workshop
produced masterpieces for
wealthy patrons. His name is

derived from a breviary
made by him for John, Duke
of Bedford, brother of King
Henry V of England, now in
the British Library. Each
page is surrounded by an
elaborate border, in which
all kinds of activity take
place, including infants
chasing each other in
mobile play-pens while
monkeys ride on the backs
of dogs. These *drôleries* are
not static scenes limited to
one page but continue over
several pages, as one chase
is replaced by another.
The borders, executed by at
least two assistants, one now
known as the Coëtivy
Master, combine with the
miniatures to form one of
the greatest works of art in
the Chester Beatty Library.

The fifteenth century was one of the greatest periods of European illumination and calligraphy, although it paradoxically coincided with the arrival of printing. Many patrons continued to employ scribes and illuminators until the mid-sixteenth century, by which time manuscript production had declined, and was reserved almost entirely for special documents or prestige volumes. This was a time when secular texts, particularly the revived classical texts, were illuminated as often as religious works.

Towards the end of this period, the format of books changed as title pages, initially in the form of frontispieces styled as Roman funerary monuments, were introduced, and new scripts devised by chancellery writing masters and humanist scholars generally replaced the over-elaborate Gothic hands. Gradually the art of the scribe and illuminator evolved to become the art of the printer and woodcut artist.

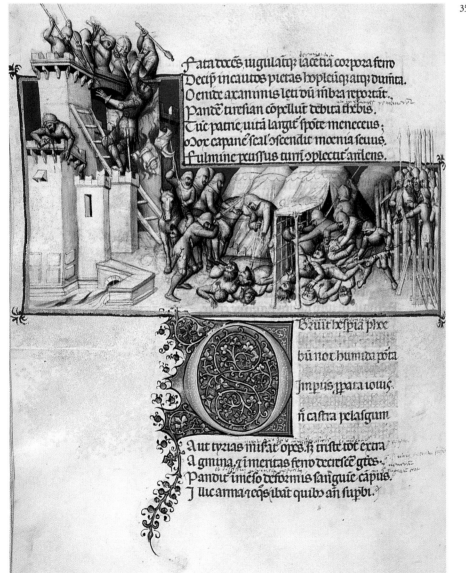

35 **Thebaid of Statius**
Latin text on vellum
*c.*1380
Italy (Padua)
33.6 × 22.8 cm
CBL WMS 76 f. 129v

Jacopo Avanzi, a close follower of Giotto, painted the miniatures in this manuscript with extraordinary delicacy, for the most part in *grisaille* and a very limited palette of strong blues and reds. They are among the most beautiful examples of the Paduan school of painting. Influenced by Giotto's frescoes in Padua, many painters copied the master, including several who also painted illuminated manuscripts. Jacopo Avanzi and Altichiero da Zevio both worked on the frescoes of St Anthony's Basilica in Padua and this manuscript shows elements of their style, particularly in the plasticity of the figures and animals.

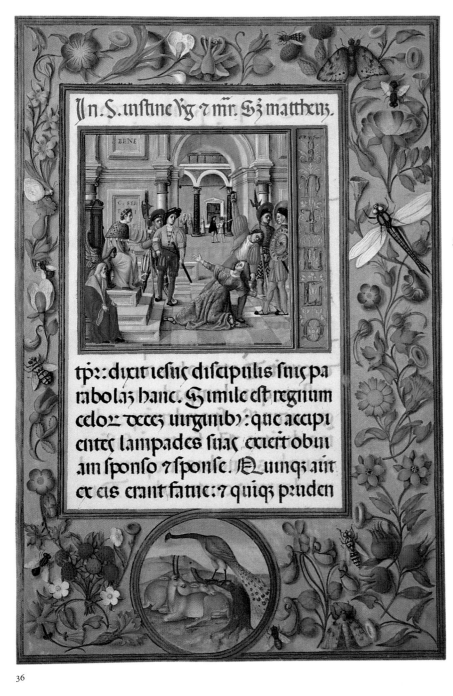

36

36 Evangeliary of Santa Giustina, Padua
Latin text on vellum (Italian Gothic
minuscule)
1523–5
Italy (Padua)
33.5 × 24.2 cm
CBL WMS 107 f. 65r

The contract between the artist and
the abbot who commissioned this
manuscript still survives, and in it we
learn that the abbot wished the artist
to use the maximum amount of
ultramarine blue, gold and other
colours. The effect of this can still be
seen today in this sumptuous example
of the illuminator's art, which
contains 75 miniatures and numerous
decorative ornaments throughout the
manuscript. The miniatures are by the
Paduan illuminator Benedetto
Bordon (*c.*1455–1530), and are
regarded by many as his most famous
work. They are also considered to be
among the most outstanding artistic
creations from sixteenth-century
Padua. Italian illuminators were often
inspired by the works of the great
masters, and in this manuscript
Bordon has included elements from
the paintings of Giorgione and the
early works of Titian.

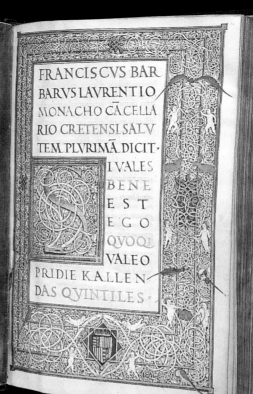

37

38

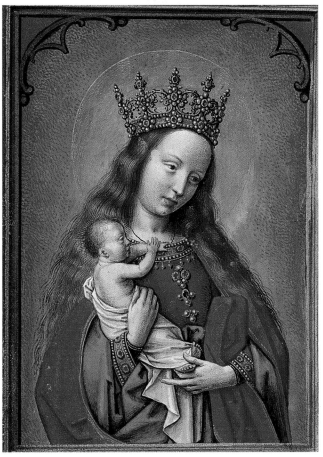

39

37 ***Epistolae* of Franciscus Barbarus**
Latin text on vellum (Italian humanist minuscule)
1472
Italy (Parma?)
33.2 × 23 cm
CBL WMS 113 ff 18v–19r

This manuscript, a copy of the letters of the Venetian senator Franciscus Barbarus (c.1391–1454), has been richly illuminated, with several pages written in gold on purple-stained vellum. The beginning of each epistle is introduced by a large initial written in gold on a coloured ground, filled with a wonderful white-vine ornament, set into a double-framed border decorated with animals and the arms of the kings of Naples and Aragon, to whom the book is dedicated. The scribe was Ioannes M. Cynicus of Parma.

38 ***De Bello Troiano* of Dictys Cretensis**
Latin text on vellum (Italian humanist script)
c.1480
Italy (Padua)
22.6 × 15 cm
CBL WMS 122 f. 3r

The Paduan scribe Bartholomew Sanvito (1435–1518), one of the principal calligraphers of his age, executed this manuscript on the Trojan War for Cardinal Francesco Gonzaga (1461–83). Faceted epigraphic capitals, similar to those that appear in Mantegna's paintings, are a standard feature of his work.

39 **Virgin and Child**
Rosarium of Phillip II of Spain (1527–98)
Latin text on vellum (Spanish rounded Gothic minuscule)
c.1530
Flemish (Bruges)
12.6 × 8.2 cm
CBL WMS 99 f. 44v

This prayer-book, also known as the Chester Beatty Rosarium, is a collection of prayers to the Virgin Mary. Simon Bening (1483–1561), the last of the great Flemish manuscript illuminators, painted 33 magnificent illuminated miniatures to aid contemplation during prayer. As the manuscript pre-dates the accession of King Phillip II, it is now thought that Phillip's father, the emperor Charles V, commissioned it.

The invention of movable type for printing books revolutionized book production in fifteenth-century Europe, and in order to meet the demand for more books, other new processes were also needed, particularly in relation to the production of paper and to the selling and distribution of the final product. Initially the design of early printed books imitated manuscripts. In part this was a consequence of public taste, as many people viewed the new books as cheaper imitations – useful, but not a replacement for a manuscript. Some guilds of scribes and illuminators initially objected to the new processes, successfully blocking the introduction of printing presses in some cities, while others adapted and became woodcut artists.

From the introduction of printing in the 1450s to the early nineteenth century, printers usually produced their books in unbound sheets. These were sold to the stationer or bookseller, who arranged to have the sheets folded, sewn and bound in order to sell them. The type of binding was normally the choice of the purchaser or bookseller, some of whom provided lavish bindings for very special books.

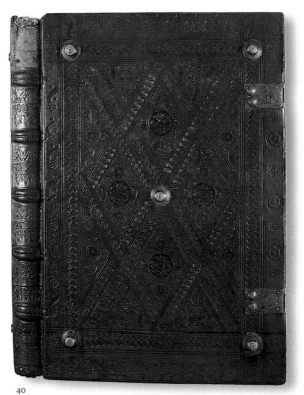

40

40 **Imperial binding (Vienna)**
*c.*1481
Quaestiones in quattuor libros Sententiarum
Duns Joannes Scotus
Edited by Thomas Penketh and
Bartholomaeus Bellatus
Nuremberg: Anton Koberger,
1481
CBL Incun. 13

The decoration of this binding is thought to be the work of the royal binder to the Holy Roman Emperor Frederick III (1415–93). The decoration is blind-tooled on calfskin over wooden boards, and is a fine example of an elaborate German Gothic binding.

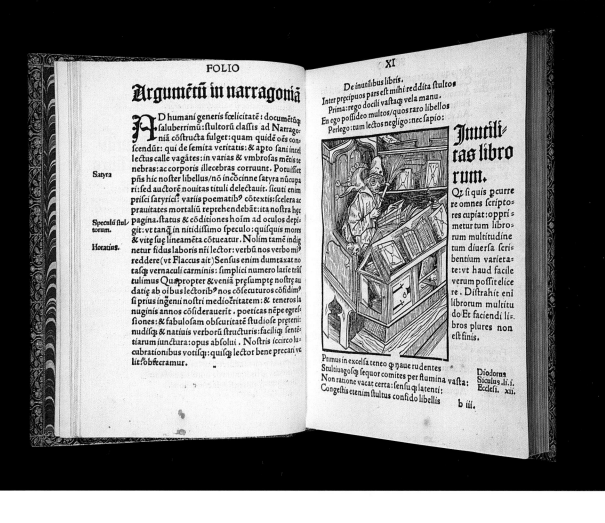

41

41 ***Stultifera Navis* (The Ship
 of Fools)**
 Sebastian Brant
 Basle: J. Bergmann, 1497
 CBL Incun. 10

The Ship of Fools, first published
in Germany in 1494, was one
of the most popular and
influential books of its time.
This copy is Jakob Locher's
Latin translation from the
original German, published in
Basle in 1497. While the book
is about the foolish nature of
man, its popularity rests to a
large extent on its 117 woodcuts.
The first passenger on this ship
of fools is the Book Fool, a man
who spent all his time
collecting books but who
never read them.

42

42 Featherwork binding (Irish)
*c.*1755
Vitruvius, *De Architectura*, and
Henry Wotton, *Elements of
Architecture*
18th-century manuscript copy
by Irish architect Michael Wills
48.4 × 31.0 cm
CBL WMS 192

Chester Beatty's collection of
bindings from eighteenth-
century Europe includes
many virtuoso examples.
This binding, recently
identified as the work of
Edward Beatty, formerly
known only as Parliamentary
Binder B, is one of the most
important Irish bindings to
survive from this period.

**43 *Les Portraits des hommes
illustres françois qui sont
peints dans la Galerie du
Palais du Cardinal de
Richelieu* ('The Most
Illustrious Men of France…')**
Portrait of Cardinal de
Richelieu
Paris: Charles de Sercy, 1650
Engraved by Zacharie Heince
(1611–69) and François Bignon
(b. 1620). Illuminated edition.
45 × 65 cm

This series of 26 portraits was
based on paintings from the
gallery of Cardinal de Richelieu
(1585–1642). It was the result of
the collaboration between the
French artist Zacharie Heince
and the engraver François
Bignon.

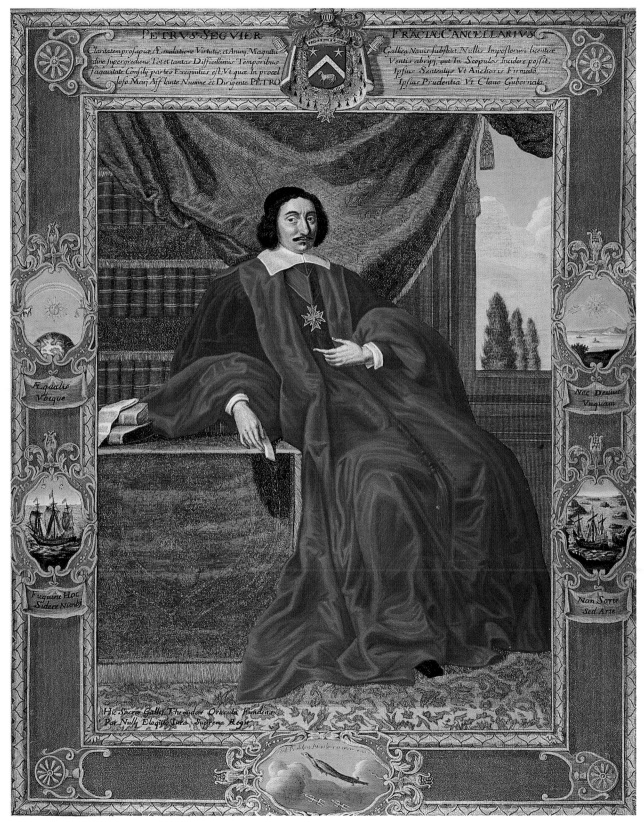

43

44 **John Gould**
*Monograph of the
Macropodidae, or Family of
Kangaroos*
London: 1841

Chester Beatty was particularly
attracted to fine books,
especially English and French
nineteenth-century colour-
plate books which depicted
views of foreign lands, military
exploits, and the natural
history and costume of various
regions. Such books were
mainly illustrated in coloured
aquatint, lithography or
chromolithography. Aquatint
illustrations were usually
printed in one or two colours,
with other colours added by
hand, whereas the finest
chromolithograph illustrations
could have anything up to
24 colours, often producing
dazzling – if at times gaudy –
effects.

45 **Twentieth-Century Bindings**
Le Jardin des Caresses,
translated from the Arabic by
Franz Toussaint. Illustrations
by Léon Carré.
Paris: Hector Piazza, 1914.
Italian binding by Gozzi,
Modena.

Voyage autour de sa Chambre
Octave Uzanne
Illustrations by Henri Caruchet.
Engraved by Frédéric Massé
Paris: Henri Floury, 1896 or 1897.
Turquoise green mosaic
morocco binding by Charles
Meunier.

Ballades Françaises
Paul Fort
Lyon: J. L. Schmied, 1927.
This volume was bound by
George Cretté (1893–1969) and
the enamel plaque of a winding
road bordered with cypresses
(J. Goulden after F.-L.
Schmied) echoes the striking
simplicity of the typography
and illustrations inside.

46 *Poèmes de Charles
d'Orléans*
Henri Matisse © Succession
H. Matisse/DACS 2001
Paris: Editions de la Revue
Verve, 1950
41.5 × 27 cm
Inscribed to Chester Beatty
from Henri Matisse, 1951

Fine books are still produced,
mostly in limited editions, by
many small specialist printers,
particularly in England,
France and the United States.
Chester Beatty collected some
of these fine modern books,
but generally his taste was
conservative. His preference
was for books where text and
image formed pleasing
compositions on the page.
He did not like modern art or
the work of avant-garde book
designers, illustrators or
binders, and such books are not
represented in the collection.

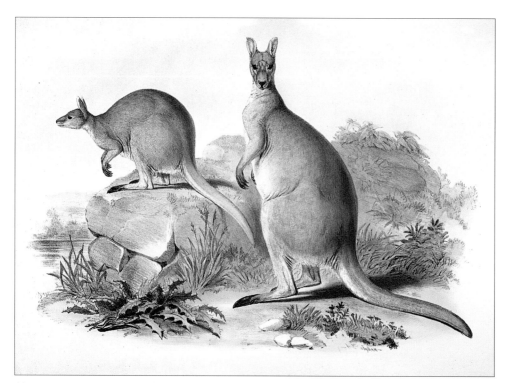

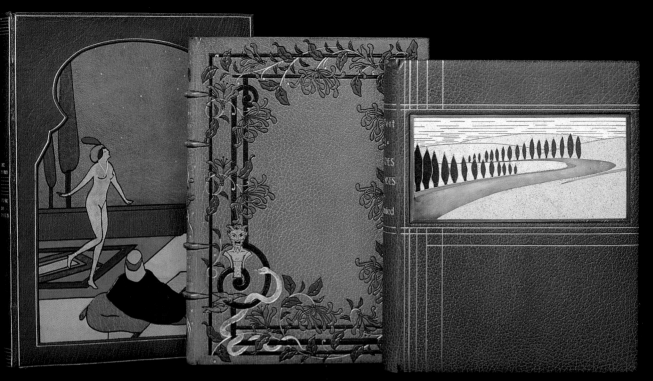

45

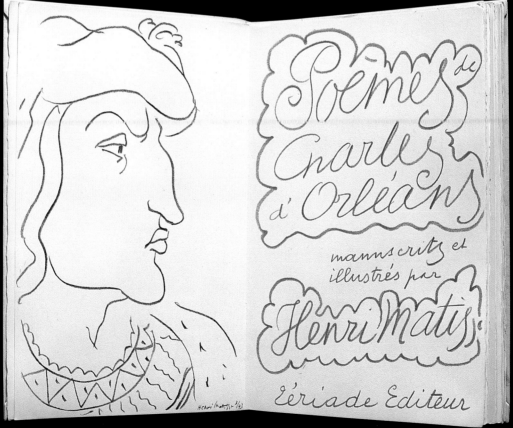

46

Throughout the eighteenth and nineteenth centuries a print cabinet was an essential element of a gentleman's library. This usually consisted of portfolios of prints or print albums arranged either by subject-matter or, more often, by artist or engraver. The European print collection formed by Chester Beatty is in this tradition. He started to collect prints around 1910, and he was particularly interested in the works of Northern European artists, especially the engravings and woodcuts of Albrecht Dürer and the group of engravers known as the 'Little Masters'.

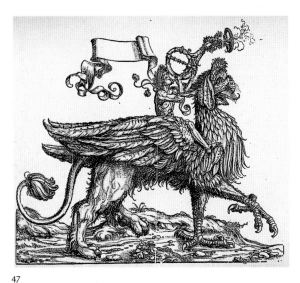

47

47 The Triumph of Kaiser Maximilian
Hans Burgkmair
(1473–c.1531)
Le Triomphe de l'Empereur Maximilien I
Vienna: M.A. Schmidt, et se trouve à Londres chez J. Edwards, 1796
CBL Wep 3134.1

Hans Burgkmair, a painter and friend of Dürer, to whom he apprenticed his son, is chiefly remembered for his remarkable skill and inventiveness in woodcut prints. His greatest work, *The Triumph of Kaiser Maximilian*, is a collection of 135 full-page woodcuts showing princes, knights, and musicians in the service of the emperor. While the wooden blocks were executed in 1517, the death of Maximilian (1519) reduced the demand for the work and it was not printed until 1526, and then in a very rare edition. The abandoned blocks were only rediscovered in Vienna in the 1730s, and it was reprinted in 1796.

48 The Four Horsemen
Albrecht Dürer (1471–1528)
From *Apocalipsis c[u]m figuris* (*The Apocalypse, with illustrations*)
Woodcut
Nuremberg, 1511
(Latin edition)
39.5 × 28 cm
CBL Wep 21

The Apocalypse woodcuts were completed in 1498, and on the reverse of each print in double columns is a Latin text for the next illustration. Dürer's woodcut of the Four Horsemen of the Apocalypse was a unique interpretation of the biblical text, and it soon became one of the most recognizable images in European art.

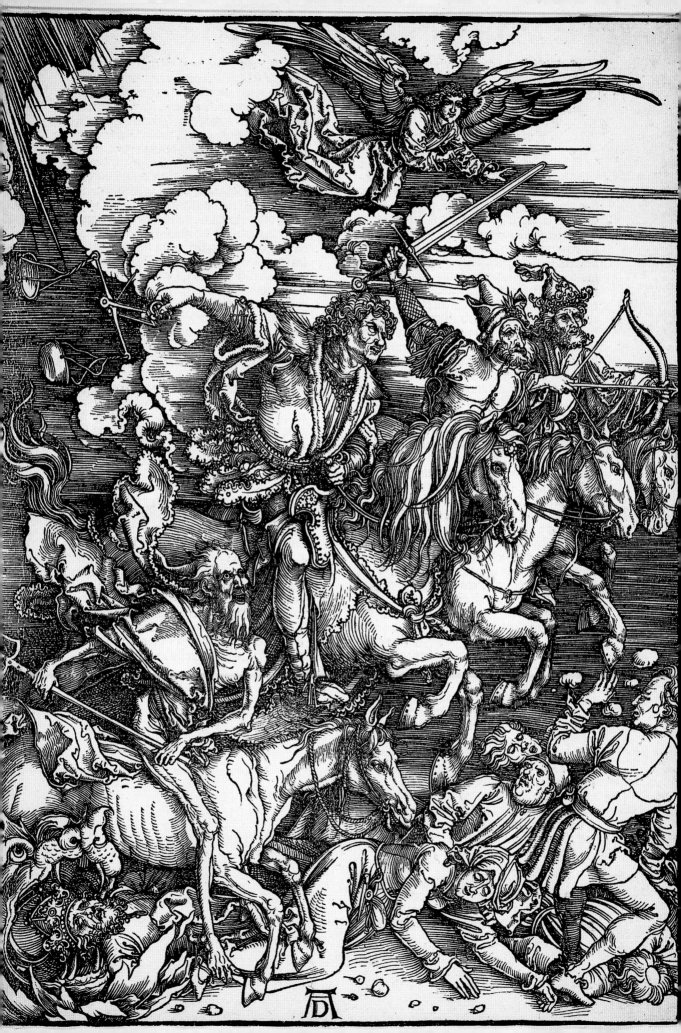

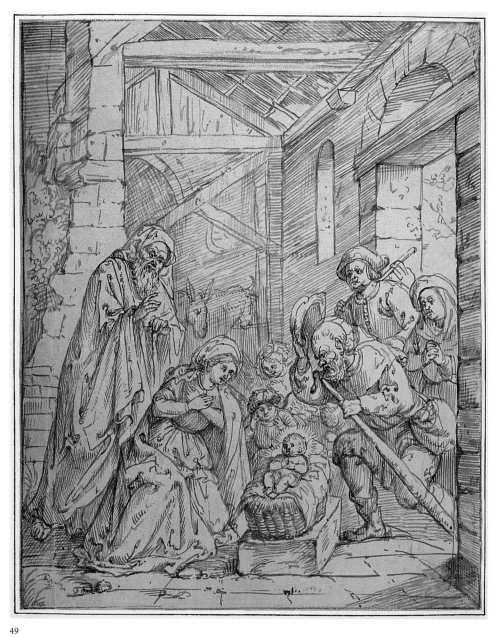

49

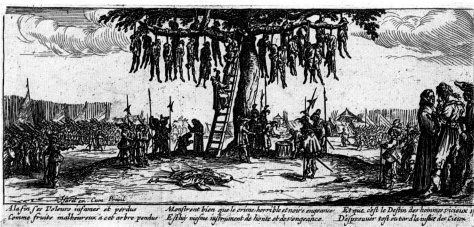

A la fin ses Voleurs infames et perdus Monstrent bien que le crime, horrible et noire engeance, Et que c'est le Destin des hommes vicieux ;;
Comme fruits malheureux a cet arbre pendus Est luy mesme instrument de honte et de vengeance, D'espouuer tost ou tard d'la iustice des Cieux.

50

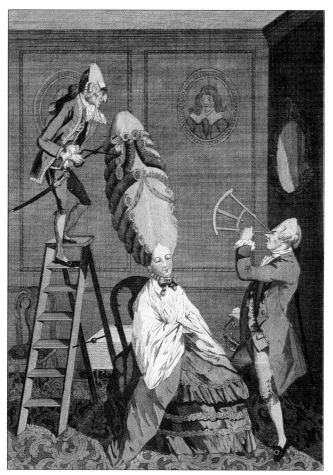

51

49 The Nativity of Jesus
Lucas van Leyden (1494–1533)
Pen-and-ink drawing
16th century
Netherlands
20 × 15 cm

Chester Beatty collected only a small
number of European drawings, the
majority of which he gave to the
National Gallery of Ireland. He kept
several albums for himself, mostly
consisting of seventeenth- and
eighteenth-century architectural,
botanical and figural studies.

50 *La Pendaison*
Jacques Callot (1592–1635)
*Les Misères et Malheurs de la Guerre
(The Miseries of War)*
Etching
1633
French
8.1 × 18.6 cm
CBL Wep 2371

Jacques Callot was one of the first
great artists to devote his life to
printmaking. His oeuvre consists of
more than 1,400 prints, 950 of which
are in the Chester Beatty Library. His
last great series of etchings, *The
Miseries of War*, displayed the horrors
of the Thirty Years War (1618–48).

**51 The Ridiculous Taste,
or the Ladies' Absurdity**
Matthew or Mary Darly (*fl.*1741–80)
From *Darly's Comic Prints of
Characters*
Hand-coloured etching
1771
English
CBL Wep 548

Social caricature enjoyed an
unprecedented degree of freedom
and popularity in England during
the last decades of the eighteenth
century. The talent of amateur artists
and their acquaintance with high
society, as well as their close
collaboration with printsellers, vitally
contributed to the creation of a
wide market for satirical prints.
Caricatures poked fun at all aspects
of social life, from the absurdities of
high fashion to the exaggeration of
physical features.

The Library's archives list 'leaves from a *Shahnama*' – the great Persian epic poem that tells of the deeds of the kings and heroes of pre-Islamic Iran – as the first Islamic material purchased by Chester Beatty, in America, sometime between 1905 and 1910. Like these first folios, much of the material that now comprises the Islamic collections was obtained through dealers, mainly based in London and other European cities. However, many of the qur'ans and other Arabic manuscripts were purchased by Beatty from dealers in Cairo. For twenty-five years, beginning in 1914, Chester Beatty spent several months of each winter in that city. In later years he visited less frequently, his final sojourn being in the winter of 1949–50. These trips were made for health reasons – he suffered from silicosis, the result of years of working in mines – but they provided ample opportunity to assuage his thirst for collecting.

Today Beatty's Islamic collections consist of over 4,000 manuscripts and single-page paintings and calligraphies, supplemented by a small assortment of objects, most notable of which are a jade qur'an stand, a brass astrolabe and wooden quadrants, a collection of semi-precious stone amulets, lacquer penboxes, a pair of wooden inlay doors, and a large assortment of detached bookbindings. Of international repute, the collections are noted in particular for the very high quality of the decorated manuscripts and the single-page paintings, almost every one of which stands as proof of Chester Beatty's discerning taste.

The manuscripts and objects were produced mainly in the Middle East and India, between the late eighth and early twentieth centuries, although certain periods and regions are more heavily represented than others. Arabic, Persian and Ottoman Turkish are the main languages in which the manuscripts are written, although a few examples of Chaghatay Turkish and Kurdish exist, and many single-page Indian paintings have inscriptions in Urdu. Chester Beatty divided his Islamic manuscripts and single-page works into five collections, according to the criteria of language, geographical region, and text-type (the Qur'an, Arabic, Persian, Turkish, and Mughal-era Indian Collections). However, the broader divisions of decorated versus non-decorated and religious versus non-religious material are also valid and are more comprehensible to the non-specialist.

The decorated manuscripts are mainly qur'ans, prayer books and works of the great poets of the Islamic world. The Qur'an is never illustrated, but other manuscripts may contain both illuminations and illustrations. (In the terminology of Islamic art, 'illumination' refers to non-figural, abstract decoration, unlike Western art usage wherein it denotes both figural and non-figural book decoration.) Usually the text is written in a fine hand on highly polished paper and bound in an intricately decorated binding. These are prestige works, made largely to proclaim the wealth and sophistication of the persons for whom they were made – the sultans, shahs and princes, members of the aristocracy and wealthy merchants of the Islamic world.

However, the majority of the Islamic manuscripts have no decoration whatsoever, neither illuminations nor illustrations. These are non-qur'anic, mostly Arabic manuscripts, covering a wide range of texts, including history, geography, medicine, astronomy and astrology, statecraft, and the religious sciences. They are largely resource

52 **Sunburst motif (*shamsa*)**
Qur'an, copied and illuminated by Ruzbihan al-Shirazi
AD early 16th century
Iran
42.7 × 29.0 cm (folio)
CBL Is 1558, f. 2a

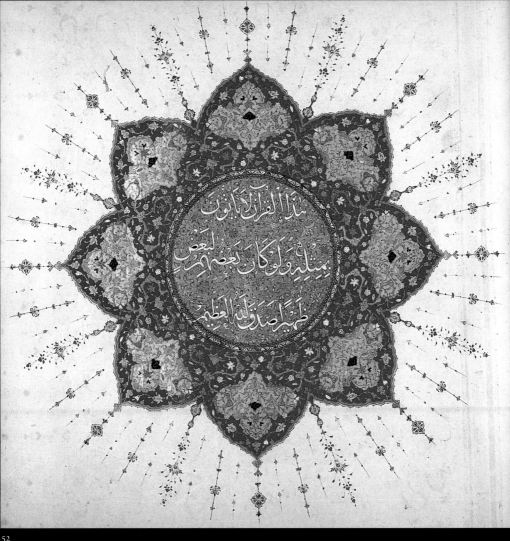

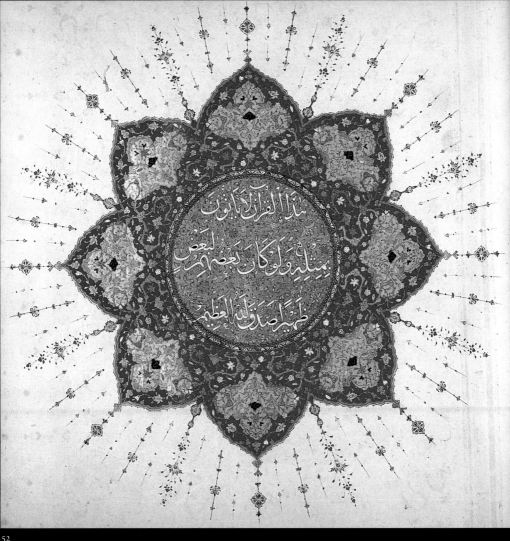

books that would have been used on a day-to-day basis by scholars, students, state administrators, religious leaders and others. A few do include simple drawings or diagrams to elucidate the text. This is a very important collection because many are unique texts, preserved only here in the Chester Beatty Library.

In addition to qur'ans, the religious manuscripts include copies of *hadith* (the sayings of the Prophet Muhammad), qur'anic commentaries, prayer books, and other texts concerning all aspects of the Islamic faith. The non-religious manuscripts – mostly poetry texts but also texts such as histories and biographies – reveal other aspects of Islamic culture.

Traditionally, the arts of the book have played a major role in Islamic culture. Sir Alfred Chester Beatty's collections of Islamic manuscripts allow the visitor the opportunity to explore this role, and in so doing, to explore equally the religion and wider culture of Islam.

Qur'ans and Other Manuscripts Expressive of the Islamic Faith

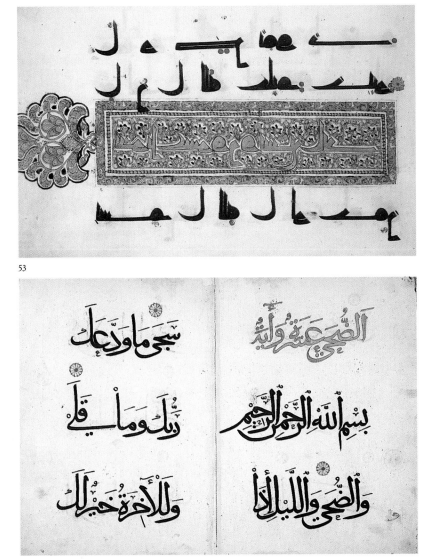

53

54

53 **Qur'an Fragment**
Heading for Chapter xxxii,
The Prostration (*al-Sajda*)
Arabic text in *kufic* script on
vellum
AD 9th century
Near East, possibly Iraq
21.8 × 32.3 cm
CBL Is 1407, f. 2b

54 **Qur'an Fragment**
Chapter xciii, The Glorious
Morning Light (*al-Duha*)
Arabic text in *tumar* script, with
gold title in *thulth-ash'ar* script,
on paper
AD early 14th century
Cairo, Egypt
33.5 × 24.5 cm (each folio)
CBL Is 1437c, ff 86b–87a

The first line beneath the gold title
is the *basmala*, the statement, 'In
the name of God, the Merciful, the
Compassionate', with which each
chapter of the Qur'an and all other
written documents begin.

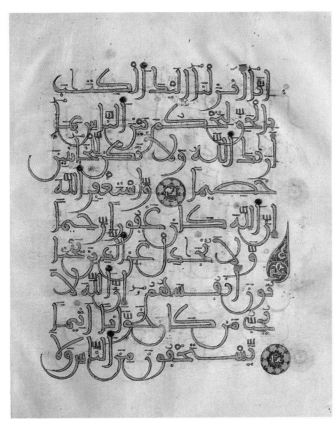

55

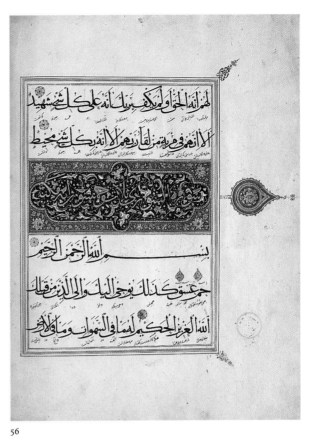

56

55 Qur'an Fragment
Chapter IV, The Women (*al-Nisa*)
Arabic text in *maghribi* script on
vellum
AD 13th–14th century
Probably Spain
27.0 × 22.0 cm
CBL Is 1424, f. 15b

56 Qur'an Fragment
Heading for Chapter XLII, The
Consultation (*al-Shura*)
Arabic text in *muhaqqaq* script,
with Persian interlinear translation
in *naskh* script, on paper
AD mid to late 15th century
Turkey
35.0 × 26.2 cm
CBL Is 1492, f. 4b

Besides the name of the chapter,
the heading also states the number
of verses it contains (53) and
where it was revealed (Mecca).

According to Islamic tradition, in
AD 610, God began to reveal His
message to Muhammad (*c.* AD
570–632), a merchant living in the
city of Mecca, in present-day
Saudi Arabia. The revelations
continued for more than twenty
years (in both Mecca and
Medina), until the Prophet's
death. The Qur'an is considered
by Muslims to be a record of the
exact words that God spoke to
Muhammad. Therefore, to copy
the Qur'an is to copy the very
words of God. It is an act imbued
with sanctity and has led to
calligraphy being the most highly
esteemed art in Islam, with the
calligrapher pre-eminent above all
other artists. A number of different
styles of script evolved, some of
which serve specific functions,
while others are peculiar to
specific regions or periods of time.

The Qur'an is divided into 114
chapters, each comprising several
verses. The start of each new
chapter is usually marked by an
illuminated heading, and the end of
each verse is indicated by an inter-
linear gold roundel or rosette.
Larger, marginal roundels guide
the reading of the holy text,
indicating every fifth and tenth
verse and places requiring ritual
prostration.

57-59 **Thirty-part Qur'an**
Arabic text in *rayhan* script,
with titles in white *kufic* script,
on paper
AD 14th century
Cairo, Egypt
26.8 × 19.2 cm (each folio)

57 **Binding of Part IV**
CBL IS 1464

58 **Part XII**
CBL Is 1465, ff 1b-2a

59 **Part XII**
CBL Is 1465, ff 2b–3a

Although the Qur'an is never
illustrated, and imagery in any
religious context is rare, the
words of God are illuminated,
often very extensively. Each
surviving *juz'*, or part, of this
30-part Mamluk Qur'an begins
with a double-page illuminated
frontispiece, followed by a
second double-page frontispiece
enclosing the opening lines of
text. Illuminated headings and
a diverse array of marginal
devices are found within the
body of the text. The main
decorative elements of Islamic
illumination are geometric
interlacements and vegetal
patterns. The interlaced vine,
which forms the border of both
of these frontispieces, and from
which spring stylized palmette
leaves, is typical, as is the
predominantly blue and gold
palette. Each part also has an
identical, finely tooled binding,
the doublures (inside surfaces)
of which are lined with
patterned leather. A typical
feature of Islamic bindings
is an angled flap that extends
from the back cover and wraps
around and protects the
fore-edge of the text block.

57

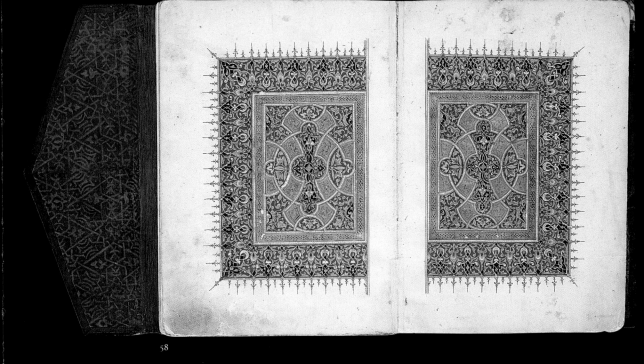

58

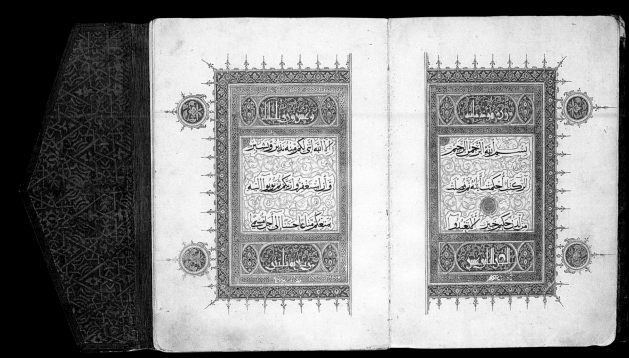

59

ولسوف يرضى
سورة الضحى على عدد آيه
بسم الله الرحمن الرحيم
والضحى والليل إذا سجى ما ودعك ربك وما قلى
وللآخرة خير لك من الأولى ولسوف يعطيك ربك فترضى
ألم يجدك يتيما فآوى ووجدك ضالا فهدى ووجدك
عائلا فأغنى فأما اليتيم فلا تقهر وأما السائل فلا تنهر
وأما بنعمة ربك فحدث

سورة اليسر على عدد آياته
بسم الله الرحمن الرحيم
ألم نشرح لك صدرك ووضعنا عنك وزرك
الذي أنقض ظهرك ورفعنا لك ذكرك فإن مع العسر
يسرا إن مع العسر يسرا فإذا فرغت فانصب

قل أعوذ برب الناس ملك الناس إله الناس من شر الوسواس الخناس
الذي يوسوس في صدور الناس من الجنة والناس قل أعوذ برب
الفلق من شر ما خلق ومن شر غاسق إذا وقب ومن شر النفاثات
في العقد ومن شر حاسد إذا حسد عليهم نار مؤصدة

سورة الليل على عدد آياته
بسم الله الرحمن الرحيم
والليل إذا يغشى والنهار إذا تجلى وما خلق الذكر
والأنثى إن سعيكم لشتى فأما من أعطى واتقى وصدق
بالحسنى فسنيسره لليسرى وأما من بخل واستغنى
وكذب بالحسنى فسنيسره للعسرى وما يغني عنه ماله
إذا تردى إن علينا للهدى وإن لنا للآخرة والأولى
فأنذرتكم نارا تلظى لا يصلاها إلا الأشقى الذي
كذب وتولى وسيجنبها الأتقى الذي يؤتي ماله يتزكى
وما لأحد عنده من نعمة تجزى إلا ابتغاء وجه ربه الأعلى

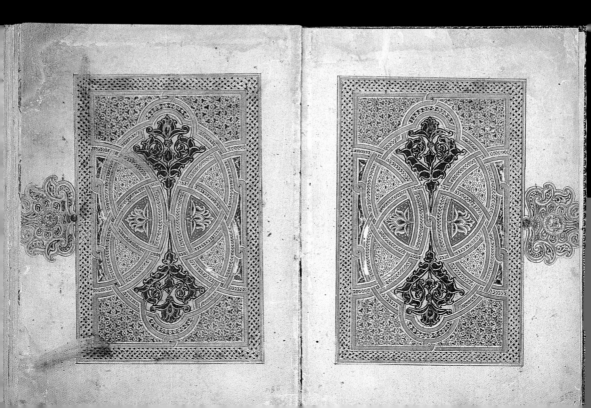

60 **Qur'an**
Chapters XCI–XCIV
Arabic text on paper
AD 1000-01 (dated AH 391)
Baghdad, Iraq
17.7 × 13.7 cm (each folio)
CBL Is 1431, ff 278b-279a

61 **Qur'an**
AD 1000-01 (dated AH 391)
Baghdad, Iraq
17.7 × 13.7cm (each folio)
CBL Is 1431, ff 284b-285a

This Qur'an is one of the great treasures
of the Library. It is important on a
number of counts, but especially as it is
a rare example of the work of Ibn al-
Bawwab (d.1022), one of three great
medieval masters of Islamic calligraphy.
Ibn al-Bawwab is especially esteemed as
a master of *naskh* script, although the
script he has used in this Qur'an is
considered by many to be a *naskh-
rayhan* variant, rather than pure *naskh*.
Nevertheless, this Qur'an is thought to
be the earliest existing example of a
qur'an written in a cursive script. It is
also important as an early example of a
qur'an copied in a vertical format on
paper. (For comparison, see CBL Is 1407,
illustrated on page 48, a qur'an copied in
kufic – a non-cursive script – on vellum
and in a horizontal format.)

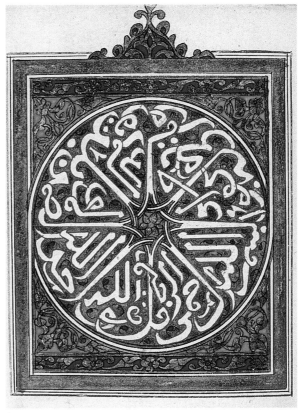

62

62 **The Guide to Happiness**
(*Dala'il al-Khayrat*)
Arabic text on paper
AD 18th century
North Africa, probably Morocco
11.0 × 10.5 cm
CBL Ar 5459, f. 3a

This text, composed in the
fifteenth century by Muhammad
ibn Sulayman al-Jazuli, is
primarily a compilation of prayers
for the Prophet, but also includes
a description of his tomb and a
list of names ascribed to him.
Copies usually also include
miniatures depicting the Great
Mosque of Mecca and the
Prophet's mosque and tomb in
Medina. The text was especially
popular in Turkey and North
Africa in the eighteenth and
nineteenth centuries. The
illumination of this manuscript
is particularly extensive, for it
includes over sixty frontispieces
and also numerous headings.

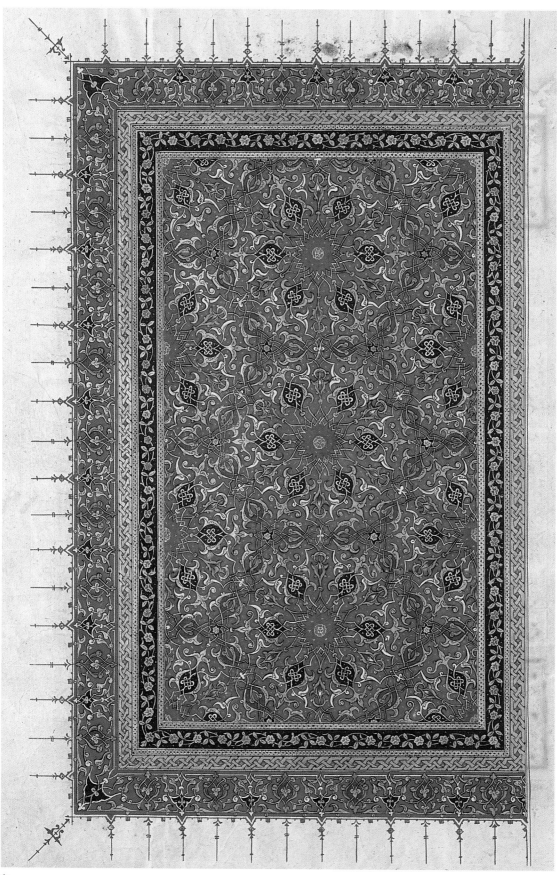

63 **Collection of Traditions**
 (*Jami' al-Usul*) **of Ibn al-Athir**
 Arabic text on paper
 AD 1435 (dated AH 839)
 Iran
 34.5 × 26.5 cm
 CBL Ar 5282, f. 2a

This is a collection of *hadith*, the
sayings of the Prophet Muhammad.
The *hadith* are one of two primary
sources of Islamic law, second in
authority only to the Qur'an itself.
This folio is one-half of a double-page
frontispiece and a supreme example
of illumination in Iran during the
period of Timurid rule.

64 **The Great Mosque of Mecca**
 The Triumph of the Holy Places
 (*Futuh al-Haramain*)
 Persian text on paper
 AD late 16th century
 Mecca, Saudi Arabia
 23.7 × 16.2 cm
 CBL Per 249, f. 19b

Mecca ranks as the holiest city of
Islam: it is the birthplace of the
Prophet Muhammad and site of the
Great Mosque, in the precincts of
which is the sanctuary known as the
Ka'ba, draped in its black cloth
covering. Muslims must pray in the
direction of the *Ka'ba*, and it is the
focus of the annual pilgrimage, or
hajj. This manuscript is an account of
the author's pilgrimage to Mecca,
which, complemented by numerous
other drawings and diagrams, serves
as a guide for pilgrims.

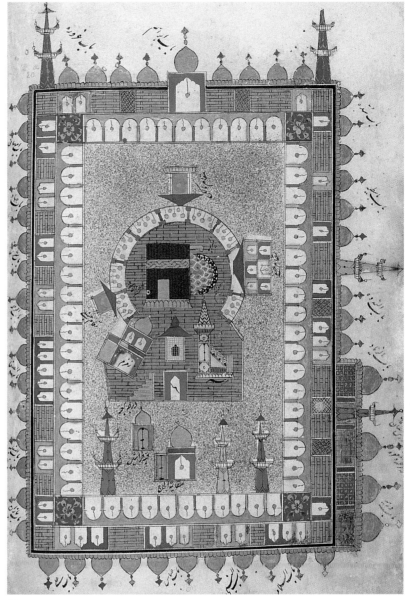

64

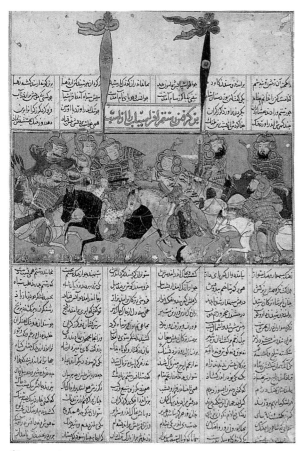

65 66

65 **Rustam and Afrasiyab in** 66 **The Sasanian King Yazdigird**
 Battle **Killed by a Kick from a Horse**
 The Book of Kings (*Shahnama*) The Book of Kings (*Shahnama*)
 Persian text Persian text
 AD early 14th century AD 1340–1 (dated AH 741)
 Iran (possibly Baghdad, Shiraz, Iran
 present-day Iraq) 37.5 × 30.0 cm
 19.0 × 13.2 cm CBL Per 110, f. 71a
 CBL Per 104.9

The hero Rustam, in his tiger-skin This folio is part of a dispersed
suit, attempts to unhorse manuscript made for the Injuid
Afrasiyab in a scene from one of *vazir*, or army commander, Qivam
the most popular of all Persian al-Din. The comparatively large
poems, Firdawsi's *Shahnama*, or figures, shallow picture space and
Book of Kings (completed about horizontal format are typical
1010), which tells of the feats of of painting in all regions before
the kings and heroes of pre- the late fourteenth century.
Islamic Iran. The origin of this However, the simplified, highly
and two other so-called *Small stylized forms of the vegetation
Shahnama*s is uncertain, but they and the red background of this
are generally assumed to have folio are characteristic specifically
been made in about 1300 in of miniature painting in the city of
Baghdad (once part of Iran, but Shiraz in southern Iran in the time
now part of Iraq). Although the of the Injuid dynasty (*c.*1325–53).
manuscript is widely dispersed,
seventy-seven illustrated folios
are preserved in the Library.

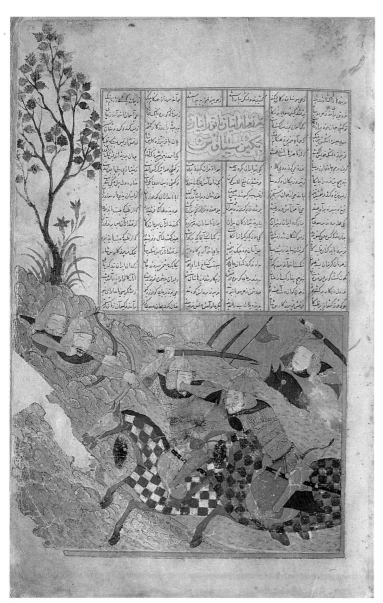

67

67 The Defeat of the Iranians at the Battle of Ladan
The Book of Kings (*Shahnama*)
Persian text
AD 1397 (dated AH 800)
Shiraz, Iran
25.8 × 16.8 cm
CBL Per 114, f. 38a

A library and the patronage of fine manuscripts were attributes of royalty and of other highly placed individuals from about the ninth century onwards. Persian princes were often artists or calligraphers themselves. They established court ateliers, employed the most skilled artists and craftsmen in the land, spent lavishly to obtain the best pigments and other materials, and frequently took a keen interest in the day-to-day activities of the atelier and its artists. Although it is not known for whom this manuscript was made, it is assumed to have been by order of a prince of the Timurid dynasty. It is part of an anthology of epic poems, the other half of which is in the British Library.

68 **An Intoxicated Prince Woos a
Chinese Maiden**
The Rose Garden (*Gulistan*) of Sa'di
Persian and Arabic text
AD 1427 (dated AH 830)
Herat, Iran (present-day Afghanistan)
24.8 × 15.4 cm
CBL Per 119.16

This miniature is part of a manuscript
made for Baysunghur, a prince of
the Timurid dynasty and one of
the greatest patrons of the book.
Baysunghur's atelier was in Herat,
the capital of the Timurids, now part
of Afghanistan but then part of Iran.
The script is *nasta'liq*, the work of the
famed calligrapher, Ja'far, and every
page of the manuscript is illuminated
with a myriad of palmette-arabesque
patterns in gold and coloured
pigments, as is the upper portion of
this folio. A weekly report written by
Ja'far to Baysunghur, detailing the
many and varied activities of his
court atelier, refers to the production
of a *Gulistan*, surely this very
manuscript.

69 **Collection of Traditions (*Jami' al-
Usul*) of Ibn al-Athir**
Doublure
AD 1435 (dated AH 839)
Iran
34.5 × 26.5 cm
CBL Ar 5282

The doublures of bindings were
often as intricately decorated as
the exteriors. Cut-work, or filigree,
doublures such as these were made
by carefully cutting patterns from
thin leather and then setting them
over a ground of coloured paper or
silk. A frontispiece from this same
manuscript is shown on page 54.

70 **The Hundred Words of 'Ali (*Sad
Kalima*)**
Arabic and Persian text
AD 15th century
Probably Shiraz, Iran
21.1 × 12.9 cm (each folio)
CBL Pers 126, ff 1b-2a

This is a collection of the sayings of
'Ali, the cousin and son-in-law of
Muhammad. The interlinear floral
motifs are typical of the work of
Shiraz illuminators.

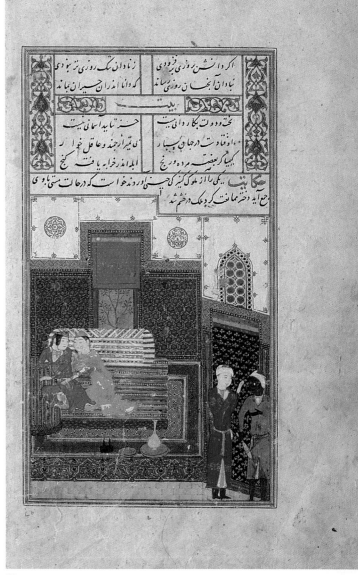

68

69

70

71 **The Old Man Encounters a Youth**
The Five Poems (*Khamsa*) of Amir
Khusraw
Persian text
AD 1485 (dated AH 890)
Herat, Iran (present-day Afghanistan)
25.0 × 16.5 cm
CBL Per 163.38

The miniatures of this manuscript are
attributed to Bihzad, renowned as the
greatest of all Persian painters. He
was the first painter to serve as head
of a royal atelier, a position previously
held only by calligraphers.

72 **The Orchard (*Bustan*) of Sa'di**
AD 1510 (dated AH 916)
Herat, Iran (present-day Afghanistan)
26.5 × 17.5 cm
CBL Per 183, f. 2a

This is one half of the double-page
frontispiece that introduces the
manuscript. Unusually, the two
halves are not identical. The style of
this half is one that was associated
with the city of Herat, capital to the
Timurid rulers of eastern Iran.
By contrast, the right half is in a style
closely linked with the cities of Shiraz
and Tabriz in western Iran.

73 **Tahmuras Defeating the Divs**
The Book of Kings (*Shahnama*)
Persian text
AD late 16th century
Iran
40.7 × 28.1 cm
CBL Per 277.17

This is part of a manuscript made for
the Safavid ruler Shah 'Abbas shortly
after his accession in 1587. New rulers
frequently commissioned a copy of
the *Shahnama*, or *Book of Kings*.
Doing so is thought to have
symbolized the new king's integration
into the long line of Iranian rulers,
thereby justifying his right to rule.

71

72

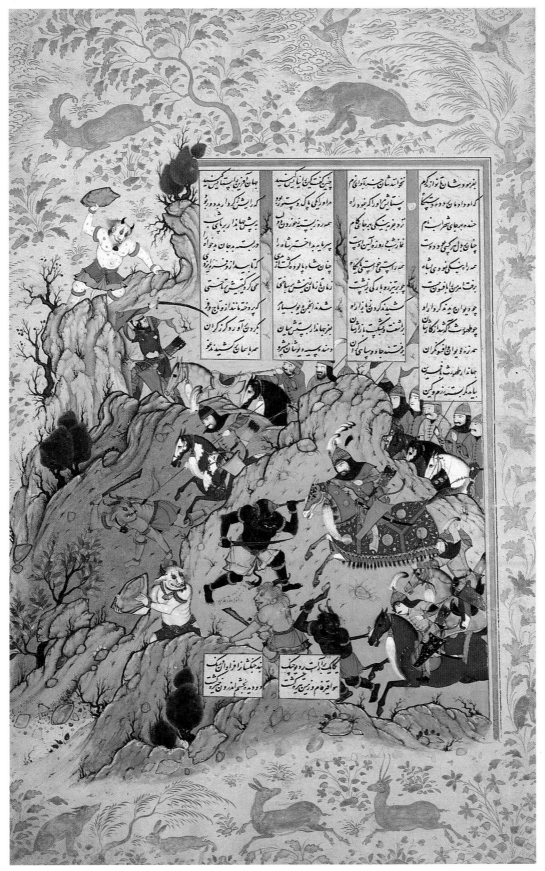

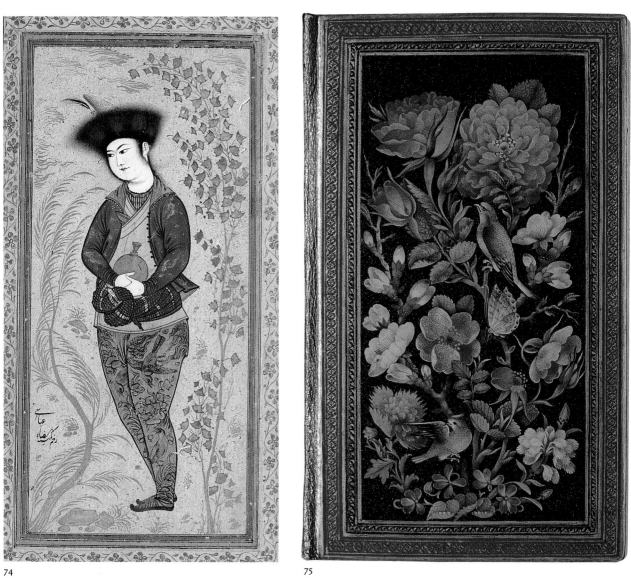

74

75

**74 Youth in a Fur Trimmed Cap,
painted by Riza 'Abbasi**
AD 17th century
Isfahan, Iran
19.1 × 8.8 cm (miniature only)
CBL Per 260.2

Riza was the most important painter of
his age. He painted elegant young
dandies such as this one, but is known as
well for his drawings of rather less refined
individuals. He was in fact criticized by
one of his contemporaries for what was
considered his rather unseemly passion
for wrestling. In the sixteenth century,
single-page paintings became popular.
These were often single images of
aristocratic youths, carefully executed
and fully coloured, such as this example
from the following century. Because
single-page paintings were quicker and
less expensive to produce than a whole
manuscript containing many paintings,
they were more widely affordable.

75 The Collected Poems (*Divan*) of Hafiz
Lacquer Binding
AD 1838 (dated AH 1254)
Iran
15.4 × 9.3 cm
CBL Per 389

Lacquer bindings such as this were
produced by painting a design onto a
pasteboard base and covering it with
layers of varnish. In Islamic lands, the
lacquer technique is most closely
associated with Iran, where it was first
used for bindings in the late fifteenth
century, then later for the production
of pen boxes, mirror cases and small
caskets. The design of this binding is a
popular one of the time, known as *gul
o bulbul*, or 'bird and flower'.

76 The Worship of Fire
Burning and Melting (*Suz o Gudaz*)
Persian text
AD mid-17th century
Iran
24.6 × 14.5 cm
CBL Pers 269, f. 8a

This is an allegorical poem, which tells of
the soul's yearning for God through the
story of a Hindu woman who, following
the custom known as *sati*, burned herself
on her husband's funeral pyre. The poem
was written for Prince Daniyal, son of
the Mughal emperor Akbar.

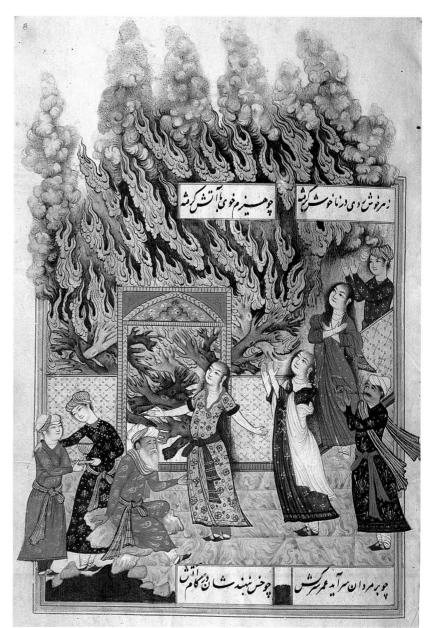

76

77 Collected Poems (*Divan*) of 'Atiqi

Persian text
*c.*AD 1465
Istanbul, Turkey
32.5 × 21.0 cm (each folio)
CBL Per 112, ff 1b-2a

Unlike Iran, where a succession of dynasties ruled various parts of the country, Turkey was ruled by one dynasty, the Ottomans, from the thirteenth century through to the early twentieth. The *shamsa* (sunburst motif) on the right-hand folio of this frontispiece once bore a dedication to the Ottoman sultan Mehmed II (*r.*1451–81), known as 'the Conqueror' because of his capture, in 1453, of Constantinople, capital of the Byzantine Empire. In book production, the Ottomans looked to fifteenth-century Iran, and then

78 The Book of Solomon (*Suleyman-nama*)

Arabic and Turkish text
*c.*AD 1500
Turkey
25.0 × 19.0 cm
CBL T 406, f. 1b

This is one half of the double-page miniature that introduces the manuscript. On the top tier sits the prophet Suleyman (the biblical Solomon, son of David), beneath the Gate of Salutation, the main entrance to the Topkapi Palace in Istanbul. On the lower tiers are the orders of mankind and the *jinn*. The facing folio depicts Bilqis, Queen of Sheba, surrounded by angels and seated above rows of monsters. The poem was composed by Firdawsi of Bursa for the Ottoman sultan Bayezid II (*r.*1481–1512), and the manuscript likewise was produced for him.

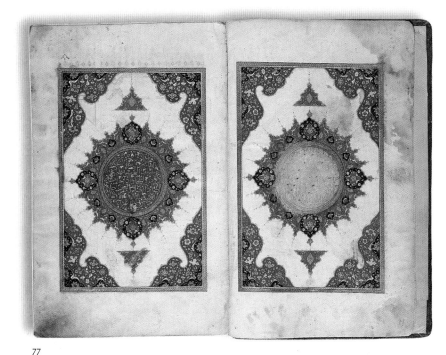

77

adopted and adapted the Persian model to suit their own tastes and needs. The illumination style of this manuscript is a case in point: although distinctly Ottoman, it derives from the style of mid-fifteenth-century Shiraz in southern Iran.

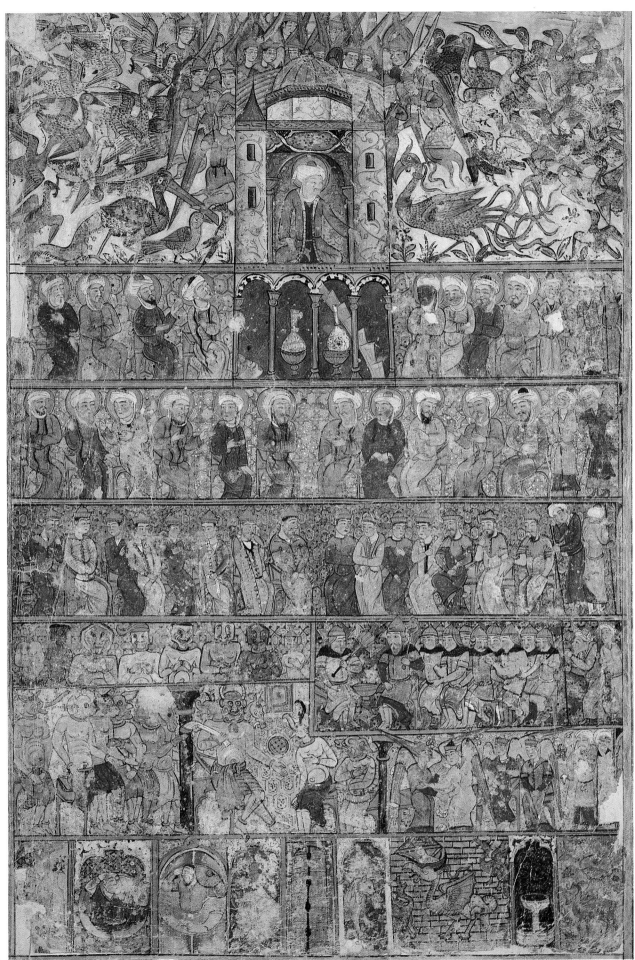

79 **The Funeral of Sultan
Suleyman the Magnificent**
*The History of Sultan
Suleyman*
Persian text
AD 1579 (dated AH 987)
Istanbul, Turkey
39.5 × 25.0 cm
CBL T 413.114

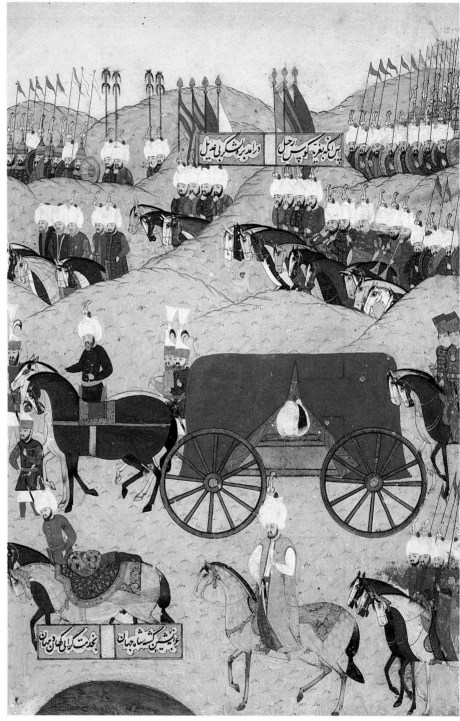

79

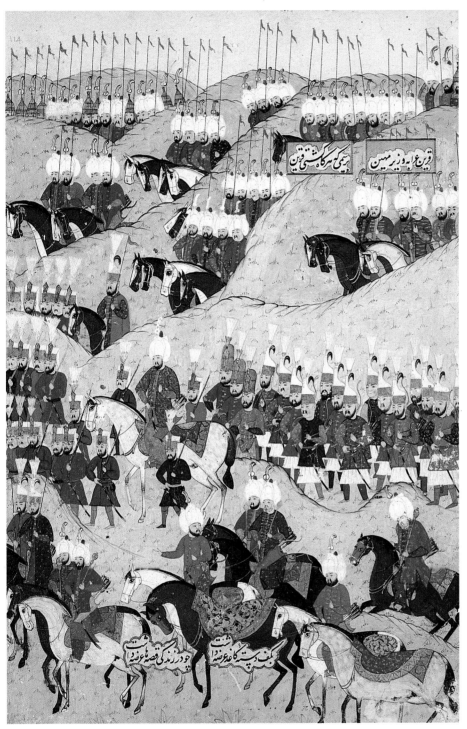

80

80 Right half of the preceding miniature

CBL T413.113

Ottoman patronage of the arts of the book (as well as architecture and ceramics) peaked in the sixteenth century. The Ottomans were especially interested in the recording of historical events and, as is evident from this double-page miniature, they developed a simple and direct style of historical illustration that aptly suited their needs. This versified account of the reign of Sultan Suleyman the Magnificent (*r.*1520–66) was written by the court historian Luqman at the behest of Suleyman's grandson, Murad III (*r.*1574–95).

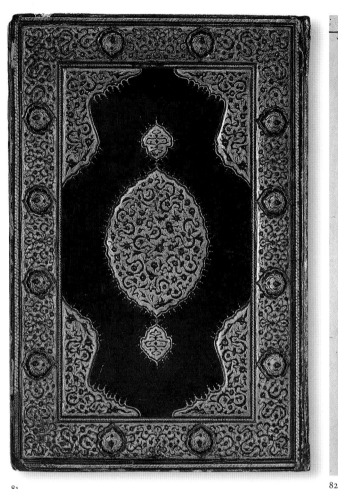

81

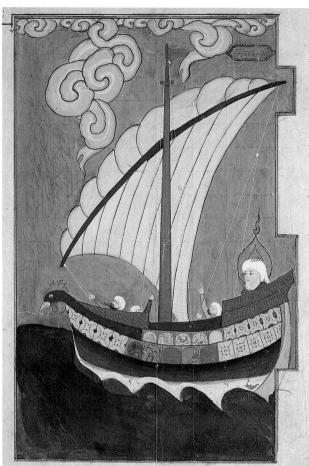

82

81 **The History of Sultan Suleyman**
Pressure-moulded Binding
AD 1579 (dated AH 987)
Istanbul, Turkey
39.5 × 25.0 cm
CBL T 413

The relief pattern of this binding was
produced by impressing a number of
stamps, each one a composite of
several different motifs, into the
leather of the cover. To produce the
gilt ground, a thin sheet of gold leaf
was laid on top of the leather before
the stamps were pressed into it.
The cloud-scroll and floral motifs
are typically Ottoman.

82 **Noah in the Ark**
The Cream of Histories
(*Zubdat al-Tawarikh*)
Turkish text
AD late 16th century
Turkey
39.5 × 25.0 cm
CBL T 414.61

In the Islamic tradition, the Qur'an is
considered the third and final portion
of God's revelation to mankind: it
completes, but does not supplant
God's earlier revelations to the Jews
and Christians, who, like Muslims,
are considered People of the Book.
The prophets of the Old and New
Testaments, such as Noah, are
therefore also prophets in Islam.
In this manuscript – a history of the
world beginning with Adam and
ending with the Ottoman sultans of
the sixteenth century – various
prophets common to Judaism,
Christianity and Islam are depicted.

83 **Muhammad and His Army March
Against the Meccans**
The Life of the Prophet (*Siyar-i Nabi*)
Turkish and Arabic text
AD 1594–5 (dated AH 1003)
Istanbul, Turkey
37.4 × 27.0 cm
CBL T 419, f. 343b

This is the fourth volume of what was
originally a six-volume manuscript
produced for the Ottoman sultan
Murad III. One volume is now lost; of
the other four, one is in New York
and three have remained in Istanbul.
The manuscript is highly unusual on
two counts, namely that it is an
illustrated life of the Prophet and that
it is so extensively illustrated – 136
miniatures in the Chester Beatty
volume alone (which is in fact
incomplete). Most miniatures portray
Muhammad, who is always shown
with his face veiled, wearing a green
robe and engulfed by a flaming halo.
In this miniature, his cousin and
son-in-law, 'Ali, rides behind him
carrying a black banner.

84

84 **An Album of Pious Sayings of Muhammad and 'Ali**
Arabic text
AD 16th-century calligraphy
AD 18th-century decoration
Istanbul, Turkey
30.8 × 20.3 cm
CBL T 426, f. 5a

This album of sayings was copied by the renowned Turkish calligrapher, Shaykh Hamdullah of Amasya (d.1520). In the eighteenth century, the folios of text were remounted in margins of marbled paper and coloured illuminations were added, attesting to the esteem in which later generations of calligraphers and patrons continued to hold Shaykh Hamdullah's work. Like most calligraphers, Shaykh Hamdullah did not restrict himself to works on paper, but also produced monumental architectural inscriptions.

85 **Qur'an**
Arabic text
AD 1806 (dated AH 1221)
Turkey
28.5 × 18.0cm (each folio)
CBL Is 1581, ff 1b-2a

This Qur'an was made for the Ottoman sultan Selim III (r.1789–1807). The impact of French rococo art, evident in the illuminations of this manuscript, was a feature of Ottoman art and architecture of the time.

بِسْمِ اللهِ الرَّحْمَنِ الرَّحِيمِ

الم ۞ ذَلِكَ الْكِتَابُ لَا رَيْبَ

فِيهِ ۞ هُدًى لِلْمُتَّقِينَ ۞ الَّذِينَ

يُؤْمِنُونَ بِالْغَيْبِ وَيُقِيمُونَ الصَّلَاةَ

وَمِمَّا رَزَقْنَاهُمْ يُنْفِقُونَ ۞ وَالَّذِينَ

يُؤْمِنُونَ بِمَا أُنْزِلَ إِلَيْكَ وَمَا أُنْزِلَ

مِنْ قَبْلِكَ وَبِالْآخِرَةِ هُمْ يُوقِنُونَ

بِسْمِ اللهِ الرَّحْمَنِ الرَّحِيمِ

الْحَمْدُ لِلَّهِ رَبِّ الْعَالَمِينَ ۞ الرَّحْمَنِ

الرَّحِيمِ ۞ مَالِكِ يَوْمِ الدِّينِ ۞

إِيَّاكَ نَعْبُدُ وَإِيَّاكَ نَسْتَعِينُ ۞

اهْدِنَا الصِّرَاطَ الْمُسْتَقِيمَ ۞

صِرَاطَ الَّذِينَ أَنْعَمْتَ عَلَيْهِمْ غَيْرِ

الْمَغْضُوبِ عَلَيْهِمْ وَلَا الضَّالِّينَ

The Library's collections of Indian material are divided between the Islamic and East Asian collections; the Islamic collection holds all manuscripts and single-page works produced during the rule of the Mughal emperors (from the early sixteenth century to the exile of the last Mughal ruler from India at the hands of the British in 1858).

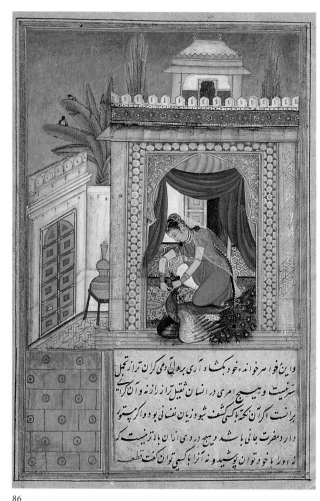

86

87

86 The Brahmin's Wife Kills the Peacock
Tales of a Parrot
(*Tutinama*)
Persian text
*c.*AD 1580
India
25.4 × 16.3 cm
CBL In 21.66

Akbar (*r.*1556–1605), the third Mughal ruler, is credited with creating the empire. One of the most avid patrons of the book known to history, a feature of his patronage was the production of manuscript copies of Indian tales, such as this copy of the *Tutinama*. Here, a woman kills a peacock that has advised her not to take a lover during the absence of her merchant husband.

87 An Egret and Two Storks, painted by Kanha and Mani
The Autobiography of Babur (*Baburnama*)
Persian text
*c.*AD 1598
India
26.5 × 15.6 cm
CBL In 06.4

Central Asia was the homeland of Babur, the first Mughal emperor, who conquered northern India in 1526. His curiosity about his new Indian domain is evident from his autobiography, in which he recorded descriptions of the plants and animals he encountered. Babur's memoir was especially popular during the reign of his grandson, Akbar.

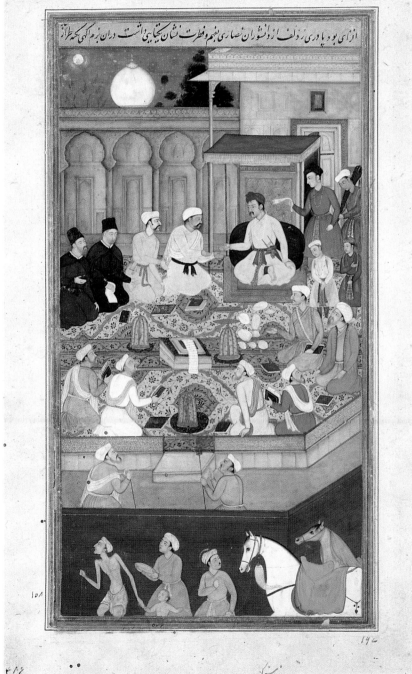

88 Emperor Akbar and the Jesuits, painted by Narsingh
The History of Akbar (*Akbarnama*)
Persian text
c.AD 1605
India
23.9 × 12.5 cm (miniature only)
CBL In 03.263

The *Akbarnama* is an official imperial biography, written by Akbar's close friend and associate, Abu 'l-Fazl. In the miniatures that accompany the text, Akbar is portrayed as a powerful, dynamic and highly heroic figure, much as he seems to have been perceived by his contemporaries. In this miniature, however, another aspect of the emperor's personality is portrayed: his intense curiosity about other religions. Akbar is shown in the midst of a theological debate with Jesuit missionaries in his *'Ibadat Khana*, or House of Worship.

89 **Shaykh Mu'in al-Din
 Chishti Holding a Globe,
 painted by Bichitr**
 *c.*AD 1620
 India
 21.8 × 13.0 cm
 (miniature only)
 CBL In 07A.14

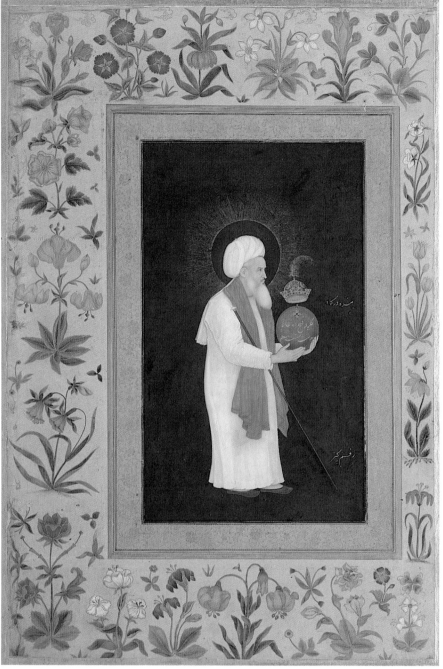

89

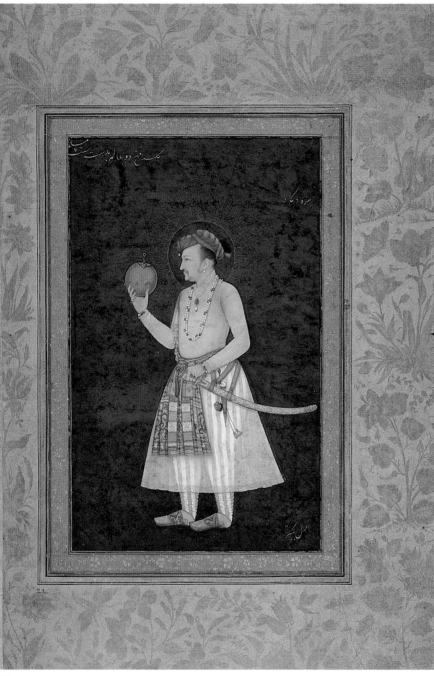

90

**90 Jahangir Holding a Globe,
painted by Bichitr**

*c.*AD 1620
India
20.5 × 12.7 cm
(miniature only)
CBL In 07A.5

These two paintings, from an
album belonging to the first
Earl of Minto, were intended
as a facing pair. Mu'in al-Din
Chishti founded the Chishti
order of Sufis in India in the
twelfth century. The Mughals
regarded the Chishti order as
their spiritual guardian. The
inscriptions on the globes held
by Mu'in al-Din and the
emperor, Jahangir (*r.*1605–27),
proclaim that 'the key to the
conquest of the two worlds is
entrusted to your hand'.
This refers to a belief that
access to inner knowledge of
the spiritual and material
worlds was through Mu'in
al-Din. Atop Mu'in al-Din's
globe is the crown of the
Timurid dynasty of fifteenth-
century Iran, symbolizing the
Mughals' vision of themselves
as heirs to the Timurid cultural
legacy.

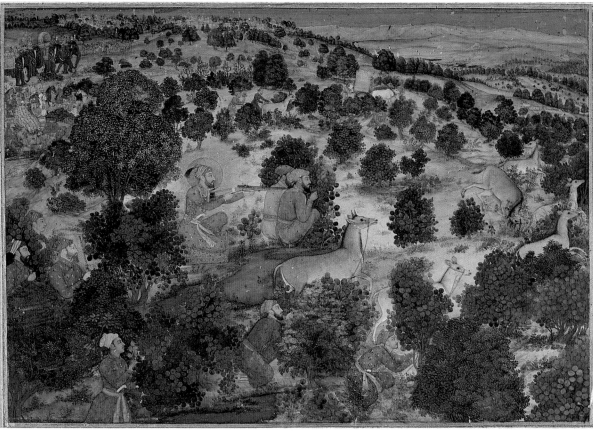

91

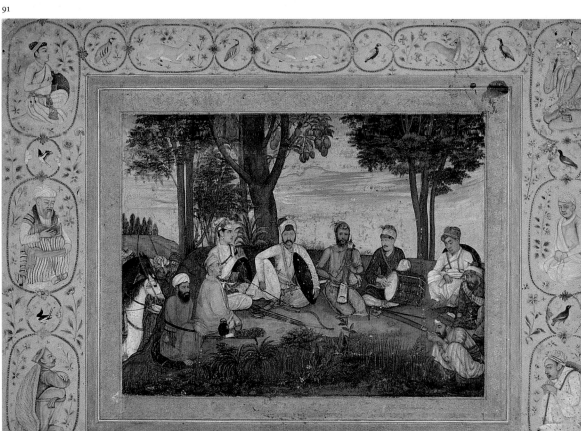

92

91 Awrangzib Hunts Nilgais
*c.*AD 1660
India
34.5 × 23.5 cm
CBL In 11A.27

The image of the hunt is
common in both Islamic and
pre-Islamic art. The royal
hunter symbolizes superior
skill, strength and heroism,
whether portrayed alone or
as part of a large, formal
hunt. Here the Mughal
emperor Awrangzib
(*r.*1658–1707) is portrayed
hunting nilgais. This
painting is, however,
essentially a landscape, a
rather rare occurrence in
Mughal and other Islamic
painting.

92 Soldiers Listening to Music
*c.*AD 1640
India
17.0 × 22.8 cm
(miniature only)
CBL In 07B.20

During Akbar's reign,
imperial painting was mainly
manuscript illustration, but
under his successors the
focus was single-page
paintings, set in exquisite,
illuminated borders and
preserved in albums. This
miniature is from an album
known as the Late Shah
Jahan Album, after the
emperor for whom it was
compiled in the 1650s. In the
court workshop, Muslim and
Hindu painters worked
together, producing a fusion,
in varying proportions, of
Indian, Persian and European
styles and techniques. In this
painting, the careful drawing
of the vegetation and the
modelling of the faces of the
musicians, in particular, tell
of the impact of European
art on the artist, who perhaps
was Payag.

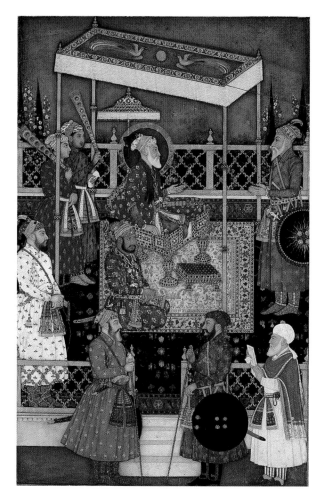

93

**93 Emperor Awrangzib
Receives Prince Mu'azzam**
*c.*AD 1707–12
India
30.2 × 19.5 cm
CBL In 34.7

This painting, from an
album compiled for Shuja'
al-Dawla, a *nawab* of Oudh,
was produced at the end
of the period of Mughal
greatness: Mughal power
and wealth and hence
artistic patronage and
production peaked during
the reigns of Akbar
(*r.*1556–1605), Jahangir
(*r.*1605–27), Shah Jahan
(*r.*1628–57), and Awrangzib
(*r.*1658–1707). Then, in 1739,
the Iranian ruler Nadir
Shah sacked Delhi, carrying
back to Iran the riches of
the Mughals – their library,
treasury and even the fabled
Peacock Throne. More
than anything, this was a
devastating psychological
blow from which the
Mughals never recovered.

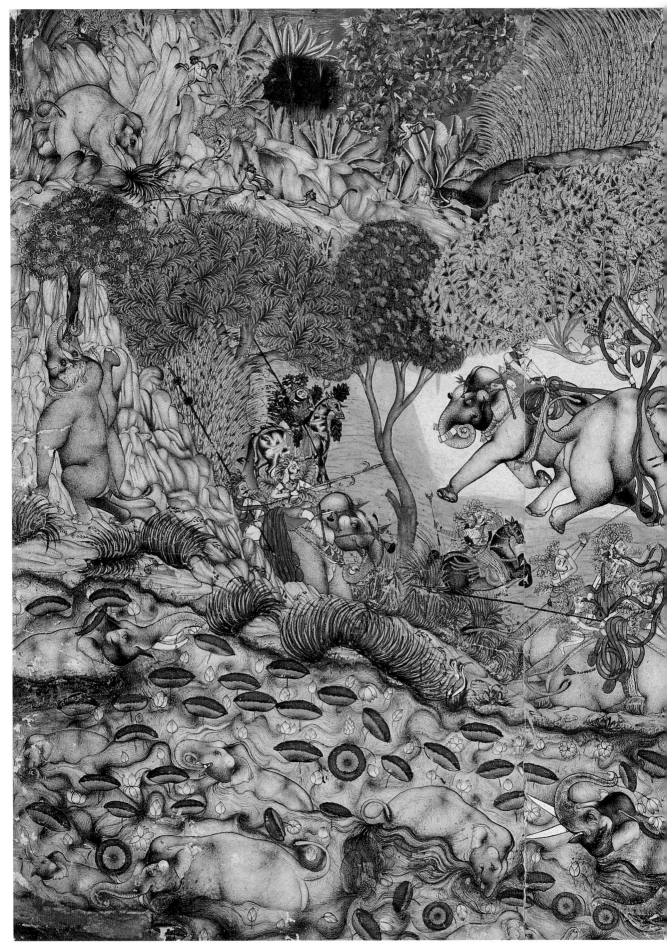

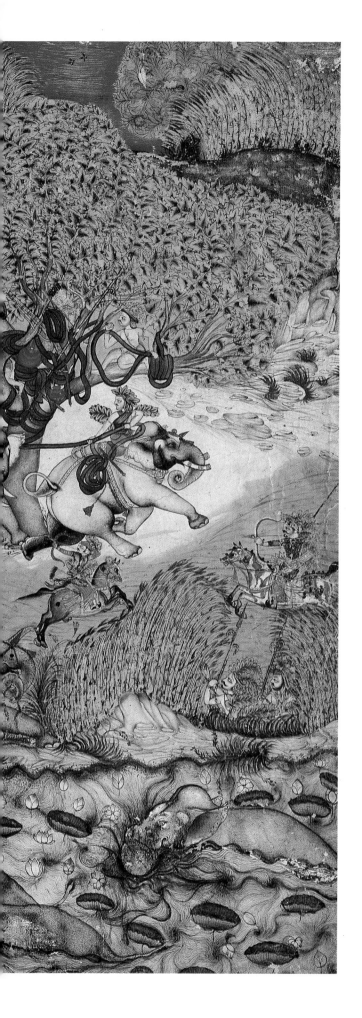

94 An Elephant Hunt
*c.*AD 1740–50
Kota, India
45.0 × 51.5 cm
CBL In 70.14

Contact with the Mughal court
influenced painting and other
aspects of life at the long-
established Hindu seats of local
power in central, western and
northern India. An increased
significance of the hunt – and
depictions of it – is one area
that can be credited to Mughal
influence. Kota, in particular,
became noted for its production
of panoramic hunt scenes, such as
this one, in which vegetation and
other landscape features are highly
stylized and intricately portrayed.

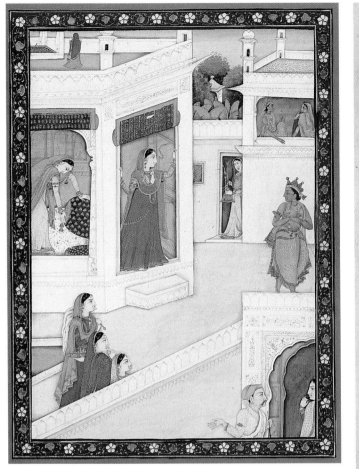

95

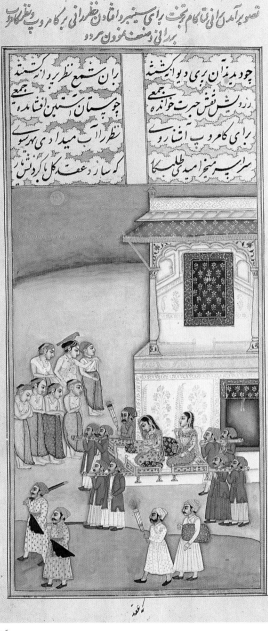

96

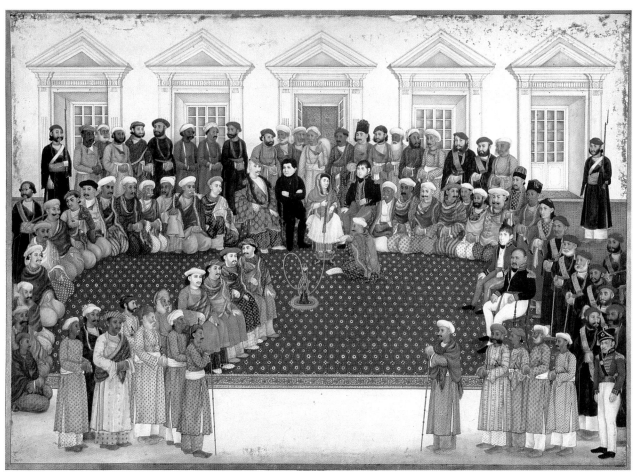

97

95 Krishna Encounters Radha
*c.*AD 1820
Jammu, India
21.5 × 15.5 cm
(miniature only)
CBL In 11B.46

Femininity, specifically
feminine beauty and
romance, was one of the
traditional Hindu themes
that reasserted itself as
Mughal control over the
Rajput states weakened.
Domestic scenes, forlorn
lovers and depictions of the
love of the Hindu god
Krishna for his consort
Radha were all popular.

**96 Prince Kamrup Assembles
an Army**
The Model of Resolution
(*Dastur-i Himmat*)
Persian text
AD late 18th century
Murshidabad, Bengal, India
33.0 × 20.3 cm
CBL In 12

Murshidabad was a major
provincial centre to which
many court artists fled in
search of employment
following the breakdown of
the centralized power and
wealth of the Mughals in
the eighteenth century.
Despite being somewhat
unusual, however, the
paintings of *Dastur-i
Himmat* (a Hindu story of
Prince Kamrup of Oudh's
peril-filled search for his
beloved, Princess Kamalata
of Ceylon) can be placed

securely within the local
Bengali painting tradition.
Production of this
manuscript would have
been a vast and expensive
project: there are 211
miniatures, many of them
full-page, and all rendered
in bright, high-quality
pigments and an abundance
of gold.

97 Begum Samru's Household
*c.*AD 1820
Delhi, India
45.5 × 62.5 cm
CBL In 74.7

This painting was made for
Begum Samru, an Indian
who employed and
entertained large numbers
of Westerners, converted to
Catholicism, and had two
European husbands. She
was powerful and wealthy,
and also, it is said, ruthless
and cruel. The painting,
which includes the name of
each individual portrayed,
incorporates both Indian
and European elements.

Chester Beatty became involved with the arts of East Asia early in his collecting career. His childhood interest in minerals is said to have attracted him to Chinese snuff bottles carved from precious stones, and he is known to have built up substantial collections of Chinese and Japanese decorative arts by the early years of the twentieth century. A trip to East Asia in 1917 added Chinese and Japanese painting to his interests, and over the subsequent decades he expanded his collections to include manuscripts, paintings, printed material and decorative arts from Tibet, Mongolia, Nepal, India, Sri Lanka and the South-east Asian countries of Thailand, Burma (Myanmar) and Indonesia.

The Chinese Collection

Chester Beatty maintained an interest in Chinese decorative arts throughout his life. There are now over 900 snuff bottles in the collection, including examples of almost all known types of material and decoration. Over half of them are made from polished minerals, with a particular emphasis on jade. Beatty's fondness for jade is also reflected in his collection of seventeen books carved from tablets of jade. Jade books are extremely rare, as they were made exclusively for the Chinese imperial family. Most of these are connected with the Qianlong Emperor (r.1736–95), a great scholar and patron of the arts, whose reign was a high point in the history of imperial jade-carving. There are over 200 carved rhinoceros-horn cups in the Library, making it one of the most important collections in the world, and Beatty also acquired a number of Chinese textiles, including seven dragon robes, the formal silk garments worn by the imperial family and court officials for ceremonial functions.

The emperors of China saw themselves as guardians of their cultural heritage. Not only did they commission and collect works of art, but they also compiled imperial encyclopaedias – compendia of existing works on a range of subjects. The Chester Beatty Library owns three volumes of *The Great Encyclopaedia of the Yongle Emperor*, a work originally commissioned by the Ming emperor Yongle in 1403 to contain 'all the knowledge in China'. The imperial collections reached their peak under the emperors of the Qing dynasty (1644–1911). Most of the Chinese objects in the Chester Beatty Library date from this period, including over 250 painted handscrolls and albums. These cover a wide range of subjects, from calligraphy, portraits and landscapes to scenes of daily life. There is also a small collection of Chinese printed material, including multicoloured woodblock prints from the late seventeenth century and printed books dating from the seventeenth to the twentieth century.

98 **The Story of Ying Ying**
Handscroll
Painted by Yu Zhiting
Ink and colour on paper
Late 17th century, Qing dynasty
China
29.5 × 420 cm (entire scroll)
CBL C 1108

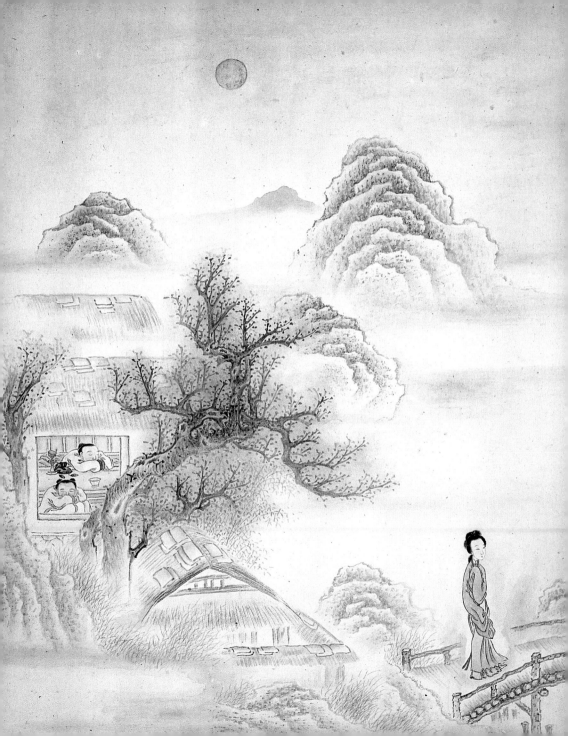

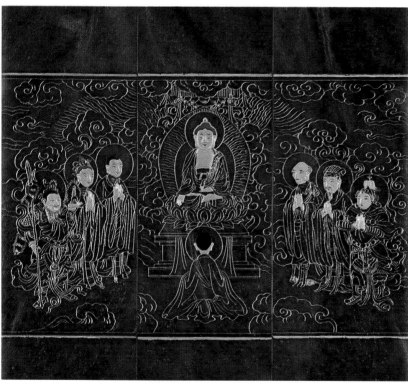

99

100

99 **The Perfection of Wisdom Sutra**
Jade (nephrite) with gold
1732
24.0 × 9.1 cm
CBL C 1006

Jade has been revered in China since
prehistoric times. Because of its
beauty, hardness and rarity, it was
associated with immortality and
believed to have magical and healing
properties. This jade book consists of
fifty-three jade tablets, engraved and
gilded with the full text of the
Buddhist doctrine known as
the *Perfection of Wisdom
(Prajnaparamita) Sutra*. These
three illustrations show the
Buddha surrounded by followers
and heavenly guardians.

100 **Snuff bottle**
Enamels on copper
Seal: Qianlong (1736–95)
18th century
China
5.6 × 3.6 cm
CBL C 482

Snuff was first introduced to China in
the seventeenth century by Jesuit
missionaries from Europe. Snuff
bottles were made from many
different materials, such as glass,
porcelain, precious stones and metal.
The technique of painting enamels on
to metal surfaces was also introduced
by Jesuit missionary artists in the
early eighteenth century. The subjects
of enamel paintings were often
copied from Western originals.

101 **Man's dragon robe**
Imperial yellow woven silk tapestry
(*kesi*), with fleece lining
18th–early 19th century
China
144.0 × 190.5 cm
CBL C 1050

Silk dragon robes were worn by the
Chinese emperor, the imperial family
and court officials for ceremonial
functions. They were elaborately
decorated with the imperial emblem
of the five-clawed dragon and other
auspicious symbols of authority and
religious significance.

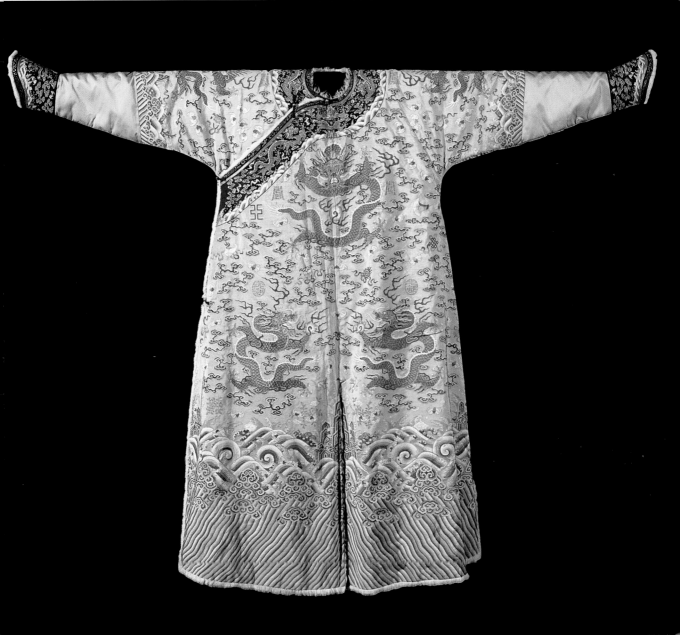

101

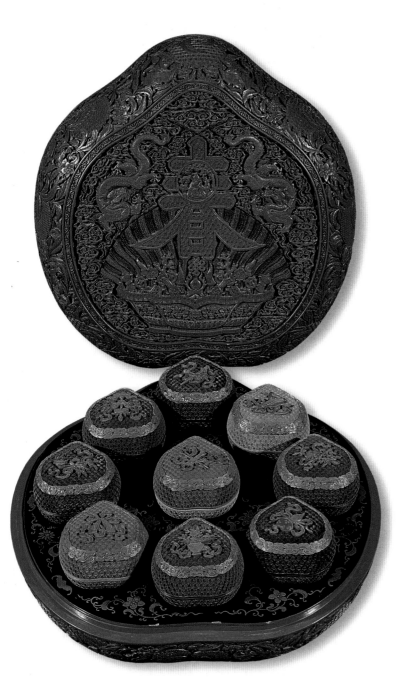

102

102 Carved lacquer sweetmeat box
Red, yellow, green, black and
gold lacquer
18th century
China
47.0 × 47.6 cm
CBL C 1084

Lacquer, the sap of the tree *Rhus
verniciflua*, is a tough, impervious
substance that has been used as a
protective coating in China since
prehistoric times. Carved
lacquer is created by applying
many coats of lacquer to a core
object and then carving designs
into these multiple layers. This
box is shaped like a peach, a
symbol of longevity. On the cover
is carved the Chinese character for
spring, inset with a roundel
depicting Shou Lao, the god of
longevity. Each of the inner boxes
is decorated with a symbol of one
of the Daoist Immortals.

**103 The Great Encyclopaedia of the
Yongle Emperor**
Ink on paper
16th century
China
50.5 × 29.5 cm (each folio)
CBL C 1758

In 1403 the Yongle Emperor
commissioned a team of
calligraphers to copy down all
existing writings on the subjects
of religion, history, literature,
philosophy, science and the arts.
The resulting encyclopaedia,
completed in 1408, consisted of
11,095 volumes. It was copied
again in the sixteenth century,
but only a few hundred volumes
survive today. The Chester Beatty
Library owns three of these rare
volumes, on the subjects of Paper
(illustrated opposite), Poetry and
Bamboo.

切義同又丞夷切唐石趙謙聲音文字通照已切从石眉顔師古有平去二音本不收俗謂用底孟引詩周道如底合正韻會定正字切知已和真

分韻 居屬

屒 隸書

氐 篆
氐 集韻見杜从古文韻海
徐鉉 唐扶頌見 隸書

歴 篆古文韻海

屒 鮮于摳見

氐 洪邁漢隸

坻
氏統 六書
坻 坺 草書錦溪見
並張錦溪見

真氐 書

坻坺

洪武正韻諸史切似摳又記摳路化為枳又溝韻許慎說文
又直尼當禮二切楊桓六書統照母坻余氏韻激母字溝韻博義諸市切
著也趙謙聲音文字通泚照已切方音見肇諸止也或作泚亦作泚渚字切知已知
義俗混坻坺富辨韻會定正也 陸法言廣韻集韻坻

枳 洪武正韻
木似橘从木只聲諸氏切錯通釋按即藥家枳棋也云枳棘棘非驚鳳
所棲清岳作開居賦枳棋帷昚也陸法言廣韻木
名久居統切忠愍佩集枳上 下側實翻打也丁底成

韻一日枳首蛇名戴個六書故孳氏切尾絡濤之柔肉味甘而中食省謂之甘故作俎若橘甘橘之類不一夫橘之類亦木一夫實厚皮肉俱不中食者曰抽小者曰枳宜入藥其小而堪食者曰柚其大多朱臧人謂之朱欒其香者為香欒其小而

橘考工記橘踰淮而北為枳此地氣然也鄭氏為枳者枳也美春王子嬰降枳道旁以為藜注供木高而多剌可為籬文縣在巴奈王子嬰降枳道旁以紫雲龍桓似林多刺釋行均龍龕手鑑音紙又居紙反楊桓六書統照母飄桓注馬口江南為橘江北為枳又行顯志賦捷忠韻會藥要次渚音晏于曰江南為橘江北為枳又行顯志賦捷忠

音韻會定正字切
知已和真趙謙
日在長安東二里趙謙聲音文字通照已切木似橘破可藥橳注馬口
以為藜注供木高而多剌可為籬文

篆說文見杜从古
書集篆古文韻海
徐鉉 書
枳 篆
枳 隸書張納碑
隸書
枳 隸

枳統照母飄余見

枳張納碑

洪

總敍

夫其隆陽之性則莫不枯橋故橋樹之江北則化而為枳又徙樹者

山海經北嶽之山其上多枳

分韻 隸

枳 漢隸字源

劉熊碑見

枳 漢隸字源 書 草書集韻

枳 隸 劉熊碑見

邁漢隸碑見

作苦三

時用力

涼簸揚

佇雲迴

知白粲

流匙滑

費吾農

夾百�ˊ穜

心

104

**104 Pictures of agriculture and
sericulture**
Woodblock-printed book with
hand-painted colours; imperial
edition (two volumes)
1696
China
39.0 × 29.5 cm
CBL C 1717

The imperial court published a
wide variety of works,
including illustrated technical
works such as this one. This
printed and superbly hand-
painted illustration of a man
winnowing rice is from a set
of two volumes showing
the different stages of rice
cultivation and sericulture
respectively. It was
commissioned by the Kangxi
Emperor (*r*.1662–1722) in 1696.

105 Rhinoceros horn cup
18th–19th century
China
17.4 × 16.2 cm
CBL C 2055

Objects carved from
rhinoceros horn have been
produced for at least 2,000
years in China, where the
material was believed to have
magical and medicinal
properties. The lower half of
this cup is carved in the shape
of a *gu*, a ritual bronze vessel
used to hold wine during
the ceremonies of the
Shang and Zhou dynasties
(*c*. sixteenth–third centuries
BC). The upper half of the cup
is carved to resemble a lotus
leaf surrounded by flowers.

105

106

107

106 **Landscape with Fishing Village**
Handscroll
Possibly by Wang Hui
(1632–1717)
Ink and light colour on paper
17th century
China
22.5 × 1162.0 cm (entire scroll)
CBL C 1106

Chinese painting was traditionally divided into the categories of professional and scholarly painting. Scholarly, or *literati*, painting tended to be of contemplative scenes, such as landscapes, and was usually done on paper with black ink and light colours. Great emphasis was placed on brushwork as a means of expressing the spirit and personality of the painter.

107 **Painting of Flowers and Birds in the Meticulous Style, in Colours, by the Emperor Huizong**
Handscroll
Artist unknown
Ink and colour on silk
18th century
48.5 × 248.9 cm (entire scroll)
CBL C 1138

Bird-and-flower painting emerged as a distinct category of Chinese painting in the eighth century AD. This handscroll is painted in the style of works by the Song dynasty emperor Huizong (*r.*1101–2), who was renowned for his ability in this genre.

108

108 Sakyamuni Buddha
Silk-embroidered hanging
scroll
1778
China
82.0 × 57.3 cm
(with fabric mount)
CBL C 1064

During the Qing dynasty
(1644–1911), Tibetan Buddhism
was the state religion of the
Manchu rulers, and there were
frequent exchanges of gifts
between the imperial court and
Tibetan monasteries in China
and Tibet. In 1778 the Qianlong
Emperor commissioned a set
of three embroidered hanging
scrolls, of the Past, Present and
Future Buddhas respectively.
This is the second in the set
and depicts Sakyamuni, the
present, or 'historical', Buddha.
An inscription on the back of
the hanging relates how the
emperor ordered a high-
ranking Tibetan *lama* to
commission this scroll for
ritual purposes.

109

110

109 The Conquests of the Qianlong Emperor
Copperplate engraving on paper
Engraved by Jean Philippe Le Bas after a painting by Giuseppe Castiglione
1769
France
52.0 × 89.1 cm
CBL C 1601

This battle scene is a proof plate for a set of sixteen engravings commissioned in 1765 by the Qianlong Emperor (r.1736–95) to commemorate his conquests of huge tracts of foreign territory. Resident Jesuit artists at the Chinese court were instructed to prepare the drawings, which were then sent to the workshop of the famous engraver Charles-Nicolas in Paris. The Chester Beatty Library has a complete set of engravings and four proof plates.

110 Scene from a romantic novel
Woodblock print with orange and brown overpainting
17th–early 18th century
China
28.7 × 29.5 cm
CBL C 1697

Although colour printing had been used since the fourteenth century in China, the technique was not fully perfected until the late Ming period. An outline block and four colour blocks have been used to make this print, which depicts two characters from the fourteenth-century play, *Injustice to Dou E*. The widowed heroine, Dou E, is approached by the evil Donkey Zhang, who seeks her hand in marriage.

Like the Chinese collection, the Japanese collection consists of painted scrolls and albums, prints and printed books, and a variety of decorative arts. These mostly date from the Tokugawa period (1603–1867), when Japan was governed by the Tokugawa family of military rulers. Early acquisitions include *tsuba* (the metal handguards used on the Japanese sword), *netsuke* (the small carved toggles used to suspend objects from the belt of a Japanese kimono) and *inro* (the decorated lacquer containers that were among the objects suspended from the belt). The core of the Japanese collection, however, is made up of over 120 painted books and handscrolls. It is particularly rich in a type of Japanese painted manuscript known as *Nara ehon*. Made in both book and scroll form, these 'Nara picture books' were produced between the sixteenth and eighteenth centuries, using a strong, vigorous style to illustrate folktales and religious stories. Other highlights of the Japanese painting collection include a depiction by the seventeenth-century painter Kano Sansetsu of the tragic Chinese love story known as *The Song of Everlasting Sorrow*, and a number of nineteenth-century scrolls notable for their documentary interest (such as a depiction of gold-mining in the Sado district). The collection also contains a small number of early Buddhist *sutras* (sacred texts) and hanging scrolls of Buddhist subjects, bought in Japan between 1917 and 1920. Purchased at the same time was one of the rare miniature pagodas known as the *Hyakumanto darani*. Dating from the mid-eighth century, these contain printed Buddhist charms that are the earliest surviving examples of Japanese printing. Printing remained a monopoly of the Buddhist temples until the seventeenth century in Japan, when growing numbers of woodblock prints – both illustrated books and single-sheet prints – were produced to meet the demands of a newly prosperous merchant class. The majority of woodblock prints from the Edo period show the world of the courtesans, actors and common people in the licensed pleasure quarters of the major cities. These prints were known as *ukiyo-e*, or 'pictures of the floating world'. The Library's collection of 450 *ukiyo-e* prints spans the 250-year history of the genre, containing superb prints by most of the major artists. Chester Beatty also collected illustrated printed books and an outstanding group of the privately published prints known as *surimono*.

111 **Group of *netsuke* (belt-toggles)**
Left: Daruma, the patriarch of Zen Buddhism
Ivory
4.7 × 2.2 cm
CBL J 187
Centre: Fox-sorceress with reversible face
Ebony and ivory
Signed: Masatsugu
6.1 × 4.3 cm
CBL J 56
Right: Ashinaga ('Long-legs')
Ivory
Signed: Masakazu
4.2 × 2.4 cm
CBL J 126

112 ***Inro* (container) and *netsuke* (belt-toggle)**
Inro: Swallows by a willow tree
Lacquer with gold and colours
Signed: Yoyusai
19th century
Japan
8.0 × 5.0 cm
CBL J 486
Netsuke: *Ryusa*-style *netsuke* with carved designs
Lacquer
19th century
Japan
CBL J 316

The kimono, the traditional Japanese garment, has no pockets, so small personal objects such as medicine and seals were kept in small containers known as *inro*, suspended from the sash. The *inro*, usually made of wood decorated with lacquer, was made up of several interlocking compartments held together by a silk cord. The *inro* and other objects, such as the purse and tobacco pouch, were hung from the sash by toggles known as *netsuke*.

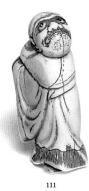
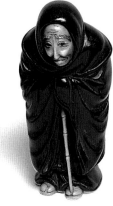
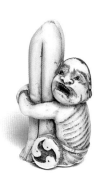

111

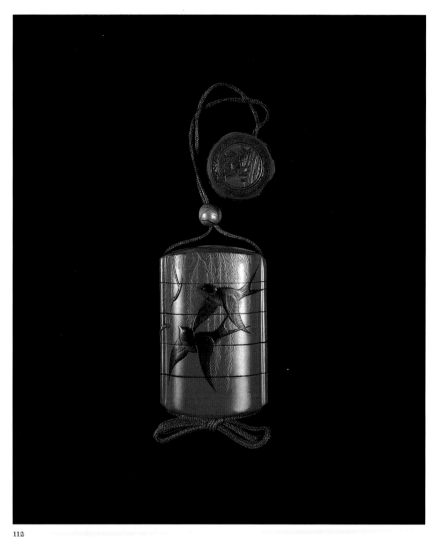

112

113

113 **Two sword guards (*tsuba*)**
Left: Iron with *shakudo* (alloy
of copper and gold) rim and
cloisonné enamel insets
Signed: Hirata Harunari
19th century
Diam. 7.5 cm
CBL J 608
Right: *Shibuichi* (copper and silver
alloy) with high-relief design of a
Noh mask and cherry blossom in
gold and silver
Signed: Nobuyoshi
19th century
Japan
7.2 × 6.5 cm
CBL J 687

The samurai sword was the
symbol of the warrior's status in
Japan. A number of sword fittings
accompanied the blade, including
the *tsuba*, the metal guard that
protected the sword hand.
The *tsuba* was pierced with one
wedge-shaped hole to admit the
sword blade, and often with one
or two smaller holes for a small
dagger and skewer.

114

114 The Tales of Ise
Book (three volumes)
Ink, colours, silver and gold on paper
Late 16th century
Japan
29.8 × 22.3 cm
CBL J 1050

The tenth-century *Tales of Ise* is a
collection of poems and linking prose
passages describing episodes in the
life of a fictitious nobleman, thought
to be modelled on the ninth-century
courtier-poet Ariwara no Narihira.
This version is a fine early example of
the genre known as *Nara ehon* (Nara
picture books). Illustrated is the
famous *yatsuhashi* ('eight bridges')
scene, where the hero composes a
poem about irises blooming beside a
series of bridges in marshland.

115 The Tale of Musashibo Benkei
Handscroll (three scrolls)
Ink, colours, silver and gold on paper
After Tosa Mitsuhiro (painter,
*fl. c.*1430–45) and Imagawa Ryoshun
(calligrapher, dates unknown)
Mid-16th century
Japan
34 × 1259 cm (this scroll)
CBL J 1117

These scrolls depict the story of
Musashibo Benkei, a legendary
twelfth-century warrior-monk famed
for his great strength and courage.
In this scene, Benkei challenges the
young warrior Minamoto no
Yoshitsune to a duel on Gojo Bridge
in Kyoto. When Yoshitsune succeeds
in defeating the mighty Benkei,
Benkei becomes his loyal retainer.

**116 Painting of the Dutch mansions
in Nagasaki**
One of two sections from a
handscroll
Ink, colours and gold on silk
19th century
Japan
33.0 × 123.5 cm
CBL J 1131

From the early sixteenth to the late
nineteenth century, all foreigners were
officially excluded from Japan, except for
a limited number of Dutch and Chinese
merchants who were allowed to trade from
the port of Nagasaki. These foreigners were
a source of endless fascination for the
Japanese. This portion of a painted
handscroll shows scenes of everyday life in
the Dutch living quarters, in the meticulous
Nagasaki School painting style.

115

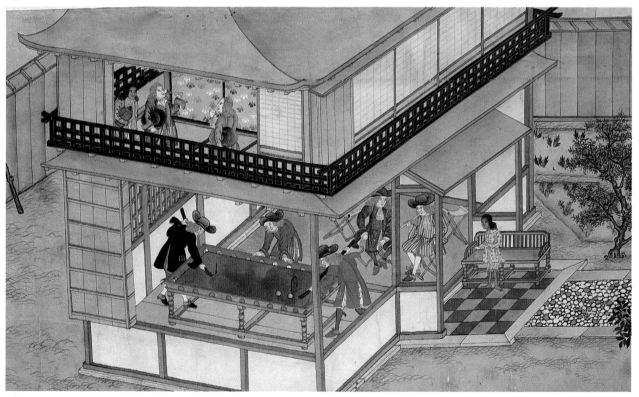

116

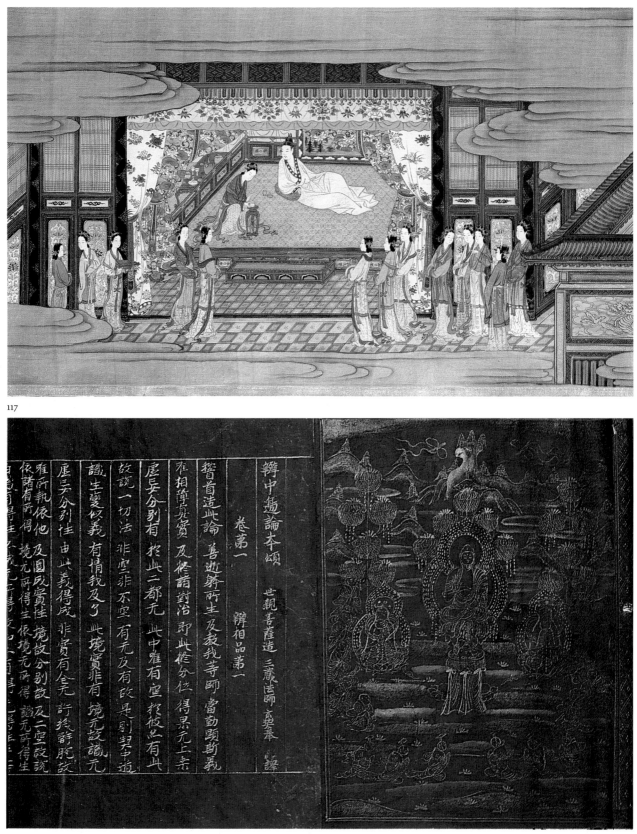

117

118

117 **The *Chogonka* Scroll**
Handscroll (two scrolls)
Colours with gold and silver on
silk
Painted by Kano Sansetsu
(1590–1651)
Early 17th century
Japan
33 × 1046 cm (this scroll)
CBL J 1158

Chogonka, translated as *The Song
of Everlasting Sorrow*, is a tragic
Chinese love poem written by Bo
Juyi (AD 772–846). Based on a true
story, it describes the Emperor
Xuanzong's doomed love affair
with the beautiful young
concubine Yang Guifei. The
scrolls were painted by the
Japanese artist Kano Sansetsu,
probably after a Chinese original.
This scene shows the Emperor
Xuanzong and Yang Guifei in their
nuptial bedchamber.

118 ***Ben chubenron honju***
Buddhist *sutra*
Handscroll
Blue-dyed paper with gold and
silver calligraphy and painting
12th century
Japan
25.9 × 140.8 cm
CBL J 1204

In the twelfth century, the powerful
nobleman Fujiwara Kiyohira
commissioned a complete copy of
the Buddhist canon as a set of
5,300 scrolls, of which this is one.
He donated the scrolls to the
Chusonji Temple, which he
founded at Hiraizumi. The
frontispiece shows the Buddha
preaching to *bodhisattvas*
(enlightened beings) and devotees.

119 **The *Bodhisattva* Jizo**
Hanging scroll
Ink, colours and gold on silk
15th century
Japan
86.1 × 38.3 cm (painting only)
CBL J 1214

In Mahayana Buddhism, the
type of Buddhism dominant in
Japan, the historical Buddha is
accompanied by a host of divine
beings, available for worship to all.
These include *bodhisattvas*,
enlightened beings who postpone
their own entry into *nirvana* in
order to help others. Jizo is one of
the most popular *bodhisattvas* in
Japan, usually represented as a
monk with a wish-granting jewel in
one hand and a staff in the other.
Jizo is particularly regarded as the
saviour of children and of those
suffering in hell.

119

120

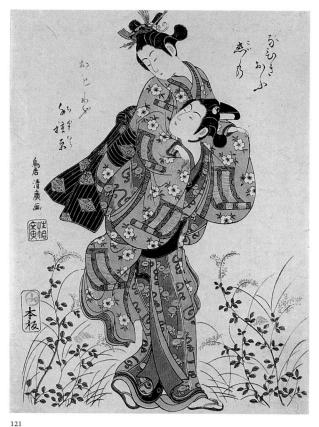

121

120 Wooden *stupa* with a printed Buddhist charm (*Hyakumanto darani*)
Turned wood with traces of gesso;
paper contents
AD 768
Horyuji Temple, Japan
Stupa: 14.0 × 10.5 cm
Printed charm: 5.7 × 53.2 cm
CBL J 1697

In AD 764, the Empress Shotoku
ordered one million miniature
wooden *stupas* to contain prayers of
thanksgiving for a victory in battle.
These Buddhist charms (*darani*) were
printed with wood and copperplates
and are the oldest surviving examples
of printed material from Japan.
The stupas were distributed to the
ten leading monasteries in Japan.
This example, containing the
Konpon darani charm, came from the
Horyuji Temple.

121 Parody of the Musashino Plain
Woodblock print
Torii Kiyohiro
1751–4
39.4 × 29.0 cm
CBL J 2404

This two-colour print, or *benizuri-e*
(pink printed picture), shows a
young man carrying his lover on his
back as the pair elope through a field
of grasses. It is an example of a
mitate-e, or parody print, depicting in
humorous, contemporary mode two
separate episodes from the Japanese
literary classic, *The Tales of Ise*.

122 Time of the Hare
Customs of Beautiful Women
by the Clock
Ukiyo-e woodblock print
Designed by Kitagawa Utamaro
After 1801
37.0 × 24.3 cm
CBL J 2533

Utamaro (1753–1806), one of the
most famous designers of *ukiyo-e*
woodblock prints, was particularly
celebrated for his elegant depictions
of courtesans and beauties. Here, two
women lean over a well, using the
water as a mirror. The 'Time of the
Hare' was between five and seven in
the morning.

123 **The Festival of the Cock Procession across the Asakusa Rice Fields**
One Hundred Famous Views of Edo
Ukiyo-e woodblock print
Designed by Ando Hiroshige (1797–1858)
1857
Japan
33.7 × 22.5 cm
CBL J 2695

Hiroshige was one of the last and greatest Japanese printmakers, best known as a designer of landscape prints. In his work he brought together elements from Japanese, Chinese and Western art, and he was particularly skilled at conveying the atmosphere of climate, season and time of day. Hiroshige's art was extremely popular in Europe and America, where his depictions of nature influenced artists such as Van Gogh, Degas and Manet.

123

124 Rooster Threatening a Painted Cockerel
Surimono woodblock print
Designed by Totoya Hokkei
(1780–1850)
1825
21.9 × 18.9 cm
CBL J 2116

The term *surimono* means 'printed object' and refers to privately published Japanese woodblock prints issued to mark special events, such as musical or theatrical performances. They were also distributed to friends as gifts on festive occasions, particularly at the New Year, when they often featured the appropriate animal from the Chinese–Japanese calendar year cycle. This *surimono* was commissioned by poets for distribution as a New Year's gift at the beginning of 1825, year of the rooster.

125 A Contest between the Beautiful Women of the Green Houses
Woodblock-printed book
Printed in ink and colours on paper
Designed by Suzuki Harunobu (1724–70)
1770
25.5 × 18 cm
CBL J 1653

Harunobu is the artist credited with perfecting the technique of full-colour printing in the 1760s. This is one of his most famous and influential works. It contains 166 colour portraits of courtesans from the main 'green houses', or brothels, each accompanied by the woman's name and a *haiku* poem.

124

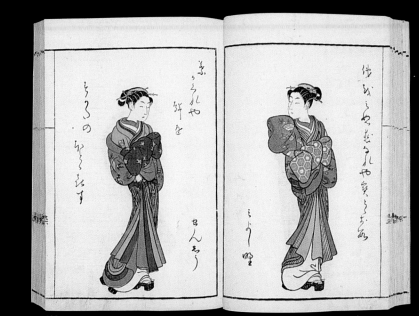

125

A number of Eastern spiritual traditions are represented in the East Asian collections. The Tibetan and Mongolian collections reflect the intensely Buddhist influence on art and book production in the region. The Tibetan collection includes sixty-seven very fine examples of the brightly painted Buddhist hanging scrolls known as *thangkas* (literally 'rolled-up object'), which were used as a focus for meditation or in the many rites and ceremonies which are an essential part of Tibetan Buddhism. It also includes sacred texts in manuscript and printed form and a group of ritual objects, such as prayer-wheels and sacred daggers. The Mongolian collection contains a small but representative collection of Mongolian religious literature.

126

126 ***Stupa (mChod rten)***
Brass with copper base
18th–19th century
Tibet
19.2 × 10.4 cm
CBL Tb 1880

The *stupa* is a religious monument symbolizing the Buddha and his final *nirvana*. It has its origins in the burial mounds built to contain the divided ashes of the Buddha's cremated body in ancient India. Many *stupas*, such as this example, are used to store sacred relics.

127 ***Mandala* of Mahamaya, the 'Great Illusion'**
Thangka painting
Colours on cotton
18th–19th century
Central or eastern Tibet
61.1 × 47.7 cm (area shown)
CBL Tb 1847

In Tibetan Buddhism, the universe is often symbolically represented as a *mandala* or 'sacred circle'. *Mandalas* have many levels of meaning, but are primarily symbolic palaces for the deity or deities depicted at the centre. They are used in special rituals and as a focus for meditation. The white figure at the centre of this *mandala* is Mahamaya, a Tibetan form of Brahma, creator of the universe.

127

Sacred manuscripts also form the core of the South-east Asian collections. Especially notable are the group of twenty illustrated Thai folding books telling the story of the famous monk Phra Malai; the extensive series of Burmese monks' ordination texts, or *kammavaca*; and the vividly painted Burmese *parabaik* folding books depicting Buddhist scenes. In the Burmese collection are also three *parabaiks* illustrating court amusements and ceremonies – a valuable record of court life before British rule. Both collections contain a number of manuscripts made from palm leaves.

Buddhism was just one of many sacred traditions making up the rich and diverse spiritual culture of the Indian subcontinent, and the Library contains a variety of religious manuscripts from India, Nepal and Sri Lanka. Among the most interesting are a fine group of Jain manuscripts dating from the mid-fourteenth to the mid-sixteenth century and a number of beautifully illuminated Hindu works.

The wide range of language and subject-matter represented in Chester Beatty's East Asian collections and the extraordinary variety of materials used are well illustrated by a group of divination books made out of bark by the Batak people of Sumatra. These were used as memory aids by priests and sorcerers.

128

128 **The Story of Phra Malai**
Colours and gold on paper;
gold and black lacquered paper
covers
19th century
Thailand
11.2 × 64.0 cm (each folio)
CBL Thi 1328

The Story of Phra Malai tells of
the virtuous Buddhist monk
Malai, who journeyed to
heaven and hell and then
returned to earth to preach of
his experiences. A didactic
account that emphasizes the
importance of *karma* (the
inevitable consequences of our
actions), it was a popular
subject of illustrated Thai
manuscripts. On the left, Phra
Malai is seen in heaven with
Indra, king of the gods; on the
right float richly dressed angels
(*devas*).

129 **The Story of Phra Malai**
Illustrated with scenes from the
Life of the Buddha
Colours and gold on *khoi* bark
paper
*c.*1850–80
Thailand
27.7 × 21.4 cm (area shown)
CBL Thi 1315

In his search for
enlightenment, Prince
Siddhartha, the Buddha-to-be,
sat down and meditated under
what became known as the
bodhi tree, or 'tree of
enlightenment', at a place
called Bodh Gaya. Mara, the
Spirit of Evil, appeared
on the mighty elephant
Girimekhala to try and
distract Siddhartha from his
meditation. Despite tempting
Siddhartha with his daughters
and attacking him with an
army of demons, Mara failed
in his attempt.

129

130

130 **Elephant Treatise**
Colours on paper; wooden
covers inlaid with coloured
glass
1816
Thailand
13.0 × 39.5 cm
CBL Thi 1301

Elephants played an important
role in Thai society, not only as
beasts of labour and battle
mounts, but also because of
their associations with the birth
of the Buddha (the Buddha is
said to have been conceived
when his mother dreamt that a
white elephant entered her
right side). Regarded as a
potent symbol of royal power,
as many as possible were
acquired in the hunt and kept
at the palace. Elephant
manuals illustrate and describe
the characteristics of elephants,
both mythical and real.

131 **The Future Buddha as a
Parrot (*jataka* 198)**
Jataka stories (181–209)
Colours and gold on paper
Mid-19th century
Burma
41.0 × 17.8 cm
CBL Bu 1206

The *jataka* stories (birth tales
of the Buddha) are legends
concerning the many previous
incarnations of the Buddha.
These folding books, or
parabaiks, were used during
the recital of the stories by
monks or learned laymen.
In this tale, the future Buddha
comes into the world as a
young parrot by the name of
Radha, cared for by a kind
holy man in the city of
Benares.

ဥဒယ်ဝါဒါ။ အသျှင်းကုးသောတန်သော်တို့ပြင်ဆင်တင်ကောတနိန်းကကြမြင်းလေပြင်ချင်းရုံသာရတန်းကိုအကြောင်း ပြုပ်ကောတော်မှရှောဘရဏာတန်။ ဟုရွှေပြင်းအံအာရာနကာတ်ပြင်ငယ်မြတ်ဘွားတန်ငှင်းမင်းတွေသည်ပြုံသည်ကျေးဒါရို့ ဘုရားလမင်းအညီးရှေကျေးသားရာ့အရှိုင်းကြီးကိုပြုံညှာဥေးသား။ ကားဝါဒုံဘေသည်ပိုက်ိုယ်သာရတော်ထိုတအာင်း ကျေးသားနှစ်ကုက်ကိုရှိုခိုင်းလာသာည်ဝါးတန်ုပြင်တွင်းတာလတ်သွားညှိတာသာရနုပ်ကို ဥဒယ်အတ်ကျော်တော်ကြီပြုဘဲ့လည်းကျေးသားကိုပို့ နှစ်လောက်တို့ဘာအေါဝုတ်ပြင်ရှိရာ့ရေညှအငေကြဲာဂွာကုံဂ်အငေင်းကေယ်းသွားညှိတော်သားပြုိနှုင်ကျေးသားကိုို့ အ်အငါ်ချက်အကူိုင်တင်ညှိ်တုကိာ့တ်ရေင်းအလုပ်တဝ်ဝဲ်ဥ်ညှစ်မိုးဖြန်ဖြစ်တွေသာအရည်ခွုကြဲိန်ုိသ်ဥ်အငာင်းပိုက်ူဝ်လ်ကျင် ိ်ဥတ်ကြု်တကြ်ုဟ်ုသူ့ိဥ်ကဖုတ်ဲ်သောအေင်ုသုဥ်လေသောဥ်ပုဏ္ဏရီဖြုသောင်ောတန်ဏ်ိုရည်ို့ိမ်ြုသောတုရှိ ုှ်ေတ်ိဇ်လ်ိသောဟာျာကုင်တို့ဥ်ုေ်ကျောင်ဝ်ိသောအေကင်ရှင်ဟုိင်ကျင်ု်လောထ်ိုဥ်ရွေ်ိာ်း।ည်ိော်မြင်ိ်ုဥ်ိရ်ရ်ုိ်ေးဥေးရ်ိ်ုဥ်ေ်းကားဥ်ုေ်ရ် ်ိ်ဥ်ုားအေ်ာင်ရှ်ိ်ိုဟ်ုာင်ုပ်ု်ဥ်ိော်ဥ်ုကြဲ်ုို့ကုယ်ိုဥ်ုဲ်ရ်ုံတ်ုံညှ်ုဏ်ိ်ာုဥ်ိ်ိ်ှ်ဥ်ဲ်ယ်ု်ိ်ံ်

132

133

134

132 Court Amusements and Ceremonies
Colours and gold on paper; wooden
covers lacquered in red and gold
Signed: Court Painter Saya Maung Gyi
19th century
Burma
40.6 × 17.4 cm (each folio)
CBL BU 1201

Scenes of royal life were a popular
subject for depiction in *parabaik*
folding books at the Burmese court of
Mandalay during the late nineteenth
century. These openings show the
training of hunting elephants and
other mounted exercises.

**133 Page from a Monk's
Ordination Text
(*Upasampada-kammavaca*)**
Lacquered cloth from a
discarded monk's robe, inlaid
with mother-of-pearl
18th century
Burma
10.0 × 54.0 cm
CBL BU 1248

When one of their sons became a
monk, wealthy Burmese families
often commissioned a copy of the
kammavaca ordination service, to be
presented to the monastery.
Expensive materials such as silk,
metal, mother-of-pearl and ivory were
generally used.

**134 Detail from the binding of a *History
of Arakan***
Palm leaf; ivory covers carved in high
relief with brass clasps
19th century
Burma
6.6 × 16.2 cm (area shown)
CBL Bu 1212

This rare ivory binding, carved in
high relief, belongs to a palm leaf
manuscript outlining the history of
the kingdom of Arakan. This detail
from the upper cover portrays the
Buddha lying on his deathbed, with
two of his grieving disciples.

135

136

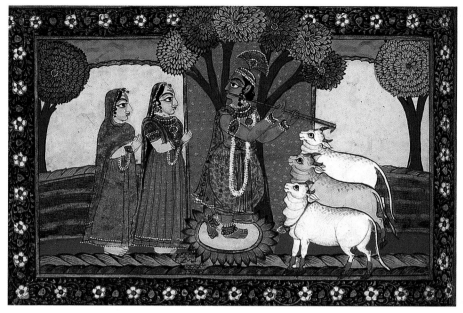

137

135 **Kalpasutra and
Kalakacharyakatha**
Ink, colours and gold on
paper
1522
Gujarat, Western India
30.5 × 11.0 cm
CBL InE 1651

The main religious focus of
Jainism is the veneration
of 24 *jinas*, enlightened
beings who have achieved
liberation from the eternal
chain of rebirth and
suffering. The last of the
jinas was the historical
figure Mahavira, a near
contemporary of the
Buddha, who founded
Jainism in the sixth century
BC. This illustration depicts
episodes from twelve years
of extreme ascetic practices
undergone by Mahavira
during his quest for
enlightenment.

136 **The Perfection of Wisdom
Sutra in 8,000 Verses
(Astasahasrika
Prajnaparamita)**
Gold ink and colours on
paper
1317
Nepal
10.3 × 36.7 cm
CBL InE 1400

According to Buddhist
tradition, the Sakya prince
Siddhartha left his wealthy
home to seek the causes
of human suffering. After
six years of study and
asceticism had failed to
reveal the truth, he began
to meditate, determined
not to move until he had
achieved his aim. Here,
Siddhartha is depicted
touching the ground with
his right hand, a gesture
that symbolizes his moment
of enlightenment.

137 **The Bhagavadgita and
other works**
Ink, colours and gold on
paper
1801
Northern India
9.6 × 14.4 cm (area shown)
CBL InE 1420

One of the most popular
Hindu deities is the
beautiful blue god Krishna,
an incarnation of Vishnu,
preserver of the universe.
Krishna is often portrayed
as a beautiful young
cowherd playing a flute,
pacifying the animals of the
forest and enchanting the
cowherd girls.

138

138 The Oracle with a Cock under a Basket
Bark with ink and earth pigments
19th–20th century
Sumatra
22.5 × 12.0 cm
CBL Sum 1127

The Batak people of Sumatra traditionally made books from the inner bark of the *alim* tree. This collection of spells and oracles begins by describing a type of divination in which a cock is kept under a basket for some time and then released on to the village square. The sooth-sayer makes his predictions by observing its behaviour.